GOLD RUSH GHOSTS OF

PLACERVILLE, COLOMA & GEORGETOWN

GOLD RUSH GHOSTS OF

PLACERVILLE, COLOMA & GEORGETOWN

LINDA J. BOTTJER

Haunted
America

Published by Haunted America
A Division of The History Press
Charleston, SC 29403
www.historypress.net

Unless otherwise noted, all images appear courtesy of the author.

First published 2014

Manufactured in the United States

ISBN 978.1.62619.459.5

Library of Congress CIP data applied for.

r

DEDICATION

*To my dear friends Margaret Hinck, Stella White and Connie Nelson, along
with Pat and Sylvia Belanger and Kathy James, who all provide infinite wisdom
and incredible strength and always make me snort with laughter.*

CONTENTS

Acknowledgements 9
Introduction 11

I. Placerville

1. The Bee-Bennett Mansion 15
2. Gold Bug Mine 21
3. Cuppa Coffee and More! 23
4. Stan Levine 26
5. The Cary House Hotel 31
6. Ghosts of Placerville's Chinese 35
7. Placerville Hardware Store 38
8. Hangtown's First Hanging 42
9. Irish Dick 47
10. A Mother's Everlasting Love 50
11. Memory Chapel 53
12. Lofty Lou's 56
13. Chamber of Commerce Building 58
14. Molly of the Fountain-Tallman Building 65
15. Pennies at 312 Main Street 68
16. The Lady in White at 537 Main Street 71
17. Placerville News Company 74
18. Spirited Fun Down at the Levee 77
19. Lions Park's Old Prospectors 81

CONTENTS

20. Placerville Soda Works 84
21. The Smith Flat House 89
22. Gothic Rose Antiques 92
23. The Children of Placerville Cemeteries 96
24. Small Specter Encounters along Main Street 99

II. COLOMA

25. Unexplained Happenings along the American River 107
26. Driving on Prospectors Road 110
27. James Marshall Monument 113
28. James Marshall's Cabin 119
29. The Vineyard House 123
30. Marshall Gold Discovery State Historic Park 130
31. The Argonaut 139
32. Sierra Nevada House 142
33. Hangings in Coloma 145
34. Coloma's Pioneer Cemetery 149

III. GEORGETOWN

35. The American River Inn 155
36. Pioneer Cemetery in Georgetown 158
37. Murder off Sliger Mine Road 161
38. Terry's Pizzeria and Grill 164
39. The Georgetown Hotel 166

Selected Bibliography 169
About the Author 175

ACKNOWLEDGEMENTS

This book's research actually began in the late 1960s. I was in elementary school when my family moved into an 1840s farmhouse in central New York. Decades of shoddy renovations had left the Federal-style house in desperate need of a major overhaul. My architect father, determined to restore its original understated symmetrical design, made it a family project. With sledgehammers almost bigger than ourselves, my late brother John and I were told "take it down."

The house's past revealed itself in the forms of nineteenth-century crockery and vermin carcasses. In the two-story barn, we discovered old newspapers, used as insulation, pasted across old boards. As each was removed, we read the weathered paper. Much of 1849 news focused on Oneida County citizens, struck by gold fever, gone to California. The romanticism of the gold rush grabbed me then and never let me go.

At the same time, Dory Marriott, a family friend, gifted us with a book on the Loomis family—upstate New York's equivalent of the Jesse James gang. She also told us our house had been a place for the gang to store their stolen loot.

While hidden treasure eluded us, the knowledge of our house's former occupants explained the odd things that happened. Strange sounds, outside of the normal old house creaks, and unusual shapes at the top of the stairs, down in the unfinished basement or outside by the side yard were accepted as normal and not feared. The otherworldly residents in my childhood home led me to accept the existence of ghosts worldwide, particularly here where the spirits of the gold rush era are found.

ACKNOWLEDGEMENTS

This book would not have been completed without the help of others. Thank you to Thomas Leigh, whose words of capturing whims, dreams and aspirations propelled me to become a better writer. Thank you to Jarrett Bottjer, who often participated in adventures near and far away from home.

Jody Franklin's guidance and enthusiasm, as the director of the El Dorado County Visitor's Authority, has proven invaluable over the past five years. When asked for information or a contact, her instant responses, and those of other staff members, has been much appreciated.

Superintendent Jeremy McReynolds of the Marshall Gold Discovery State Historic Park in Coloma graciously allowed me access to the park's vast resources on the gold rush from where it began. Park employee Gerald Kessler's professional and personal historical knowledge made days spent researching not only enlightening but fun as well.

To the El Dorado County Historical Museum Research Room's staff and volunteers who welcomed my questions, shared their personal experiences and gladly brought me books, newspaper clippings and photos—thank you.

Thanks also to the City of Placerville's Planning and Zoning Department for letting me sit in their conference room and pore through old, almost forgotten books in search of Main Street history.

Much of my gratitude goes to the merchants, fellow history lovers and those with a real connection to the supernatural who willingly shared their stories and experiences, folklore tales and time with me.

To you, the reader, this book will allow you to discover the supernatural wealth of Gold County from her places to her people—both dead and alive.

Hopefully you will have a chance to explore our spirited history soon.

INTRODUCTION

They came by the thousands, all driven by a single dream: gold. As part of one of history's largest mass migrations of people, Argonauts trekked across continents or sailed for months from distant ports. Upon arrival in California, many headed first to the foothills of the Sierra Nevada, where the gold rush began in 1848. James Marshall's discovery of golden flecks alongside the American River shoreline in Coloma forever altered lives, including his own.

Nearby settlements of Georgetown and Dry Diggins, later to be called Hangtown and Placerville, rapidly built up. Blisters bloomed on the hands of European aristocrats, booksellers from Boston and Chinese coolies as they all swung pickaxes through hard rocks and panned freezing waters of rivers and creeks.

Prospectors' enthusiasm to strike it rich soon collided with reality as the harsh lifestyle and backbreaking work took their toll. Hard times, hunger and poverty were often the only reward, followed by sickness and death.

Such was the fate of Robert Salle James, the father of future outlaws Frank and Jesse James. He arrived in Placerville sometime in early August 1850 to dig for gold and preach to his fellow miners. By August 18, he was dead of cholera. James's burial was like that of many unfortunate souls. A grave was hastily dug, and rarely in a cemetery. Before the dead were laid to rest, mourners would typically search the gaping hole for any signs of the precious metal. If none was found, the corpse was placed in the makeshift grave and covered with a few shovelfuls of dirt.

No marker commemorated their final resting spots, leaving friends and families across the globe to always wonder the outcome of a loved one.

Their restless souls still inhabit the places where they once lived and died. This is not surprising if one considers the number of bodies still under the foundations of nineteenth-century buildings, especially along Placerville's Main Street.

Murder and mayhem were gold rush byproducts. Punishment often came with a noose thrown over a tree's sturdiest branch. Violent men in life live on in a violent afterlife.

To the richly toned tapestry of our local gold rush's history, I have woven in stories of El Dorado County's spirited past. They were gathered through oral interviews from those who have experienced them. Newspapers of the nineteenth, twentieth and twenty-first centuries provided more information, as did books, videos and long-forgotten city records.

Some experiences are my own. Several occurred during our Ghost Tours of Placerville, while other encounters manifested as I went about my normal routine.

When visiting the majority of the sites listed in this book, it is still easy to see them as the Argonauts did. With this book in hand, you have a fun and informative guide to our ghosts. Their gold rush origins makes them twenty-four carat. Enjoy them thoroughly.

PLACERVILLE

CHAPTER 1

THE BEE-BENNETT MANSION

B ee Street is one of Placerville's shorter streets, but on it is found one of the city's most imposing Victorian buildings. The Bee-Bennett mansion has changed greatly since its earliest construction in 1853. Now known as the Sequoia Wedgewood, it serves as one of the region's best-loved wedding venues. The tasting room for the Nello Olivo Winery, found in the stone basement, provides some spirit. The house also possesses unfermented spirits from the past.

Ghostly sightings of young mothers and children, strange noises and cold spots have been reported for decades during the twentieth and now into the twenty-first century.

The original structure was a home for Colonel Frederick Bee, an early Mother Lode arrival. His varied business interests expanded California's future from establishing the Pony Express and a telegraph company over the Sierra Nevada range to railroad construction and owning a winery. One of the earliest pioneers to strongly protest the horrible treatment many Chinese immigrants endured, Bee was made an honorary mandarin by the emperor of China. His commitment to protect was demonstrated by building a tunnel from Placerville's Chinatown to under his own house. Emerging on the other side of town, the often-abused Asians continued safely to their vegetable gardens and gold fields.

Yet in a life filled with great accomplishments, sorrow also plagued Bee. His young son Willie died of the croup at the tender age of less than two years in 1855. A small weathered grave, alone under a grove of trees at the Old City Cemetery, is where he eternally sleeps.

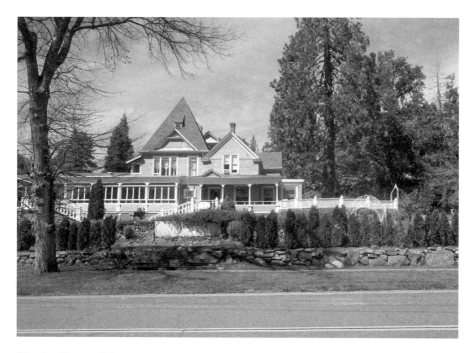

The Bee-Bennett Mansion.

Following Bee's move to the Bay Area to pursue new business opportunities, two other families, the Conklins and Duncans, lived in the house at 643 Bee Street.

By 1889, a young couple, Marcus and Mary Bennett, purchased the property. They increased the home's size to include sixteen rooms. Elaborate late Victorian touches included Oregon redwood and a tin ceiling along the verandah. In America's Gilded Age of the latter nineteenth century, the Bennetts were among Placerville's upwardly mobile residents. Harvard-educated Marcus Bennett served as an El Dorado County superior judge. Along with those of his beloved wife, called Molly, his many civic works stood as testament to the couple's dedication to Placerville and a tragedy in their own family.

Like the Bee family years earlier, death claimed two of the Bennetts' young children. Marie was only months old when she died, while her brother and the couple's only son, Marcus Jr., was dead at the age of three. Psychics have reported that the young boy's tumble down the mansion's grand staircase had proven fatal.

Molly was inconsolable at the loss. Although she continued as a pillar of the community until her own demise at age ninety, her spirit continues to

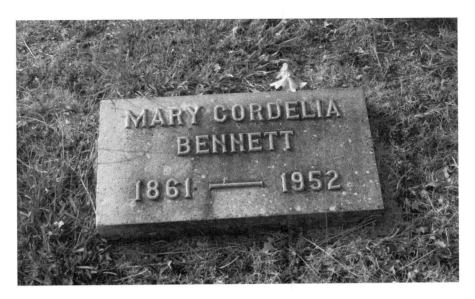

Bennett family plot, Placerville Union Cemetery.

be seen in the house and by the family plot at Placerville Union Cemetery, located directly across the street.

Her most frequent haunt is up on the second floor. Now called Molly's Parlor and used by bridal parties before the wedding ceremony, many have been startled to catch a quick glimpse of a small woman in elegant late Victorian garb. She materializes regularly to staff members of Camino Flower Shop, whose floral designs regularly grace weddings. In 2014, Molly, dead for over sixty years, was seen on the sweeping staircase by the shop's owner, Dottie Cole McKenzie, and a mother of a bride. A few weeks earlier, her entity appeared in the form of fast-moving mist to McKenzie's daughter, Matti. Some feel she continually seeks the joyous energy a wedding emits to combat the sadness she experienced in her early adulthood.

Her husband's spirit, however, was still in a depressed state when first discovered in the 1960s. By then, his former home had been bought by the Placerville Elks Lodge No. 1712. Used for meetings and events occurring from early morning to late evening, different cooks were employed for the next five decades. One claimed to have seen Judge Bennett sadly gazing at nothing from a wing-backed chair in the main dining room. It had been his former study. Her description of a forlorn, middle-aged man with a beard and wearing a brown three-piece suit was confirmed by city residents who remembered the old lawyer, dead since 1925. Although he and Molly, in

honor of their late son, had given the city an adjacent edge of their property to be used as a park, it had not been enough to wipe the sorrow from his soul, old-timers remembered.

The park was gradually absorbed into the athletic field of present-day El Dorado High School. Children's happy laughter has been heard upstairs, yet no children are ever found playing in the rooms.

The cook's adventures with the dead continued. As in the sightings of others' spooky meetings, the ghosts came from various decades of Placerville's past, including the heady gold rush days.

In preparing for a big dinner one night, she was busy in the kitchen. Frequently, at such times, the members' wives would pitch in to help without advance notice. She thought nothing was odd when one volunteer arrived. After putting her to work, the cook noticed another arrival at the other side of the kitchen. Happy for the assistance, she walked toward the woman, without failing to notice her less-than-modern attire. The white dress with thin blue pinstripes appeared Victorian, as did the pioneer-era bonnet covering her hair. The cook's curiosity turned quickly to horror upon realizing the figure before her ended about the knee. It appeared the bonneted lady was floating. The shock factor increased as the specter suddenly faded away.

Recovering slightly, the cook asked the first volunteer if she had seen the other woman. Her answer was affirmative and even included a brief description of the pinstriped dress.

Her final phantom encounter sent the cook packing. Walking from the outside, she noticed a couple rocking gently on the front porch swing. Failing to recognize them as she approached, she offered a smile, which the man and woman politely returned. It was not until inside when a sudden question hit the cook. When had a porch swing been installed?

Racing out to the porch, she found not only the mysterious couple missing but also their swing.

Later, a cook named Scotty had some unexplainable things happen. Hailing from Scotland, she had a special affinity for those who had passed over, and one ghost was especially keen on her. While cooking, she sometimes felt someone softly breathing on her neck. While alone in the house, the *tap tap tap* sound of someone walking across a wooden floor with a cane was heard. Could it have been an older Molly, who lived in her old house until her death?

During the Elks' ownership of the Bee-Bennett mansion, it was not just women who experienced supernatural occurrences. Ted Mederios served as Exalted Leader from 1989 to 1990. Often, his duty was to open the

building. Once, the building did not want to cooperate. He needed to enter through the back door leading to the kitchen. Having opened it, he took two steps to disarm the alarm when the door closed by itself. This left him in semidarkness, as the kitchen was pitch black, and its light switch was located on the other side of the room. Annoyed, he walked back to reopen the door.

Leaving it wide open, he retraced his steps, but as his back was turned, the door again closed. This time it clicked its own lock.

"The hair on my arm stood straight up," he recalled.

It took him a moment, but after a quick "aww, the hell with it," he summoned his courage to walk into the opaque gloom, across the tiled floor and find the light switch.

He also recalled that the secretary's cat, a permanent resident of the house, would occasionally refuse to enter through the front door. From its perch just beyond the door's threshold, it would look in but then seek another entryway.

Another official recalled being in the building late at night while finishing paperwork. Only after locking up and reaching his car did he realize he had left important papers back in the upstairs office. His return was greeted by the cat meeting him on the staircase. About halfway up, a cold breeze misted over him. Certain he had closed every window before his earlier departure, his concern turned to terror when a hand suddenly touched his right shoulder.

Spinning around to find no one, his fears quickly mounted as the cat inexplicitly hissed and tore up the stairs with her fur on edge. Never again would this Elk be alone in the building, especially at night.

However, others had equally chilling daytime stories. Starting soon after the millennium of the twenty-first century, the house underwent a multimillion-dollar restoration as Danika and Nello Olivo transformed it into the much-acclaimed Sequoia restaurant. Many of the house's late nineteenth-century architectural showpieces were brought back to their original splendor or lovingly replaced.

Often, such restorations awaken former occupants, eager to explore new surroundings and inhabitants. Sometimes their curiosity manifests as pranks, and at the Sequoia, there were plenty—especially with water and lights.

Toilets flushed without human contact, while water flowed from various sinks overnight only to be discovered by staff the next day. Inside security monitors captured lights blazing after being turned off. Impish giggles followed phantom footsteps heard creaking along on the stairs.

When an office was being created upstairs in the attic, a general manager checked on the progress only to be surprised by the people in the construction

zone. Instead of wearing jeans and hardhats, an observant couple stood in period costume of a bygone era.

The spirits of the Bee-Bennett House have extended beyond the physical building, as well. Saucy Hill lived for several years in an apartment above the former carriage house in the beginning of the new millennium when the Sequoia restaurant was newly opened. Once in a while, the acidic aroma of cigarette smoke would waft into her home. Neither she nor her boyfriend smoked, and the restaurant was closed, yet the distinctive scent circulated from room to room before disappearing. Could a former groomsman or chauffer with a nicotine habit still be in his former work and living space?

In another odd happening, Hill's set of Indian wedding bells once tinkled a bright melody. Alone in the apartment, she reported that there was no breeze to create the sound.

Unfamiliar with the sad deaths of the Bees' and Bennetts' young sons until I told her during our interview, Saucy was slightly shocked as she recounted another story. A visiting friend's little boy refused to take a nap in a room whose window faced the old house. He mentioned seeing other children when none were there—at least not living ones.

CHAPTER 2

GOLD BUG MINE

The city of Placerville possesses something that no other municipality in California has: a gold mine. Annually, thousands of tourists come to Gold Bug Mine Park to don hard hats and enter the 352-foot vertical mine

ler goods, groceries, &c &c., by rivals from the United States and nd are now offering great induce- purchasers We especially invite lerchants and dealers in general to place ; from the much enlarged v on hand, and expected arrivals, be enabled to make full and com- tions, and at low prices

———oOo———

> through the country on the North : Bay San Francisco, " to be con- ball appear next week

———oOo———

lore prisoners have escaped from ent within the past week, in this One of them was the person for robbing Smith & co.

ney expended in making and fil " large box" at the foot of Clay uld have paid for the construc- substantial prison:

Collection of
Phil Pickert
San Francisco.

———oOo———

A horse race came off at the Dolores Mission course, (3 miles from town) on Monday, March 6th, between a horse of W. A Leidsdorff 's, Esq , of this place, and one of Mr Hedspath of Sonoma. The judges decided in favor of Hedspath's, he being a little ahead of the other at the coming out place. We are not acquainted with the language of the turf, and consequently can give only common parlance

———oOo———

X GOLD MINE FOUND.—In the newly made raceway of the Saw M ll recently erected by Captain Sutter, on the American Fork, gold has been found in considerable quantities. One person brought thirty dollars worth to New Helvetia, gathered there in a short time California, no doubt, is rich in mineral wealth , great chances here for scientific capitalists. Gold has been found in almost every part of the country:

Facsimile of the first printed notice of the discovery of gold— From Californian, San Francisco, March 15, 1848.

ling you with this communicatio While I admire with unfeig every effort on the part of our suppress vice of every descript promote peace, order and quie refrain from expressing my cond any attempt, directly or indirectl; our social atmosphere by malign or superfluous extravagances. istrate having a regard for his the man go," he says. Does mean or allude to the time of his ducted by the town constable to witnesses? If so how miserably he. I would tell him for his per mation, that any or every indi saw the transaction, can testify stable being armed with a revol which he carried in the positio while escorting him to point out duals capable of furnishing the information calculated to acc ends of justice; therefore it is man was permitted to go at larg true that he was armed with an his knife having been taken fr detained by the magistrate; on t

Early newspaper article on gold's discovery. *Courtesy of California State Parks, 2014.*

shaft. The mine, called the Hattie after one of the owner's eldest daughters, began operations in 1888.

While its beginning came thirty years after the start of the gold rush, the Hattie is not the only on-site mine. Big Canyon Creek streams through the park before it enters the American River. This meant sizeable yields to the Chilean miners who first cut through the earth to create the Silver Pine and Priest Mines. The latter reaches down sixty feet below the surface of the ground.

The Hattie attracts the most people, but no contact with former prospectors has ever been reported. By making special arrangements, the Priest Mine can be toured, and perhaps some old miner will show up. Over the years, such apparitions have been seen by hikers on the trail near the mine. What is heard are the sound of pickaxes mixed with the distant smatterings of Spanish being spoken. The voices are too far down the shaft to be understood clearly. One witness said the tones were conversational, without any hint of stress, unlike those near Georgetown's American River Inn, where a mine cave-in occurred.

A visit to the Gold Bug Mine couples the past and the present with persons from Placerville's bygone eras sometimes appearing as tour guides.

CHAPTER 3

CUPPA COFFEE AND MORE!

According to Placerville city records, the building at 442 Main Street has been standing since July 14, 1855. The brick structure, in the Gothic Revival architectural style, was built for Caspar Hart, a South Carolinian. He and his family used the building as a residence. Further information on Hart's occupation or his family remains a mystery. The only facts found are that Hart sold the house five years later and returned to Charleston during the early years of the Civil War.

Over the next 150 years, the different owners, tenants and types of businesses that were in the building have often gone unrecorded. Lacking such facts has frustrated the owners and staff of Cuppa Coffee and More!. Armed with more information, it might make it easier to communicate with their entities.

Since 2010, the restaurant has provided fresh-brewed drinks, made-from-scratch baked goods and other food. Owner Jill Barnes and chef Melissa Arcona were told prior to moving in that the building had a spirited past. They came in the form of two main specters named Tom and Amy.

Barnes said Tom was supposedly a young man in his twenties who has proved to be an eternal jokester. Shortly after the coffee shop's grand opening, Tom made his presence known with his first prank. A store manager, alone early one morning, was completing his tasks prior to welcoming the day's customers. An extremely conscientious and tidy person, his routine was exact. Finishing the public area, he entered the kitchen and returned a few minutes later, deeply shocked by what he found.

Normally, the tables and chairs in the cove area were arranged in a way to encourage conversation between patrons and the eatery's staff. Instead, one chair had been pulled out and away from its table. It was turned so it faced a grandfather clock hanging off an opposite wall.

During the business's first year of operation, Barnes recalled often seeing in her peripheral vision a vapor hovering near the ceiling.

She said, "My first reaction was always, 'Is that smoke?'" Luckily, it was not.

Perhaps, as long maintained, it came from the gun used to fatally shoot Tom in front of the shop. Had in life his jokes and horseplay found an unappreciative audience who carried a gun? With early city records consumed in a 1910 fire, no one knows exactly, but local legend persists over the centuries.

Another ghost, Amy, described as a ten-year-old girl, also frequents Cuppa Coffee and More!. She, too, has a penchant for mischievous pranks. This preteen phantom especially loves to play with modern-day items like the radio and the kitchen's paper towel dispenser.

Starting in 2010, Chef Arcona found yards of brown paper towels pooling under and around the dispenser on first entering the kitchen for the day. Amy soon amped up her playful antics. Arcona, with her hands deep in soapy water, was taken aback several times when endless streams of towels flowed less than four feet away. A mechanical defect was soon ruled out. The dispenser had been replaced, and the same model, found in the restroom, never acted oddly. Her annoyance at the waste led the chef to verbally address the little ghost.

This appealed to Amy. To this day, she prefers to be in the kitchen where Arcona, herself a mother of two preteens, now mixes reprimands, songs and everyday conversation with her. Amy's responses typically come in the form of the rise and fall of the sink's water pressure.

Recently, Arcona expressed out loud her sadness of not knowing more of Amy's past life. She inquired if the little girl had lived upstairs or downstairs. The question received an answer of upstairs with the sudden rush of water. Had there been a store downstairs? More water. Had she worked down there? The water stream shrank to a trickle. Intrigued by the responses, the chef attempted to discover how Amy had died. Had it been an illness? An accident?

Suddenly, an overwhelming scent of ammonia filled the air. It was so stifling that Arcona had to reach for her inhaler.

Several hours later, she recounted the story to me. Sitting at a table in the eatery's cove area, once again Arcona was struck by the overpowering aroma

of ammonia. Seated less than three feet away, I smelled none of it. However, Amy has made her presence known to me. During our first interview for this book, I sat huddled in the back pantry with Arcona while on a conference call with Barnes. My back was to the kitchen when I received a hard pinch on my upper left arm.

"That's Amy," declared Arcona.

Music is important to Amy and possibly Tom. Their tastes run to the classics with a preference to Sinatra over hip-hop. Should the music not be to their liking, the entities' displeasures are quickly manifested through odd actions. They either switch the radio's channels or make the machine unplayable.

Earlier tenants of the same building had similar experiences. In the late 2000s, Mel and Kari Guthrie were about to open a bakery when they contacted local psychic Nancy Bradley. They wanted answers for the baffling events occurring at their store. Bathroom tissue rolls flew off storage shelves. Sheets of paper towels unfurled, and hung photos crashed to the floor. The CD player frequently stopped working. After taking one of our Ghost Tours of Placerville, Kari sent me an e-mail with a linked account of what had occurred.

Bradley and her team experienced cold spots, often the result of spirits' inability to produce heat, and sensed the presence of at least two ghosts. The entities were felt to be in the bathroom and kitchen.

Over the years, Cuppa Coffee and More!'s staff has accepted the many unexplained phenomena. One, however, was especially chilling.

Like many of Main Street's nineteenth-century buildings, the heavy and imposing metal back door on number 442 once acted as protection from devastating fires that had ripped through Placerville during the 1850s. Between the bolted iron door and the coffeehouse's interior is a more modern wooden door. Neither is frequently opened.

During both the pre-dawn hours while baking or at night after closing, Arcona has often heard odd knocking coming from outside. This is odd for several reasons. One is that the door faces the patio of a neighboring restaurant. When the noise has happened, the other restaurant is closed, and the patio gate locked tight. Secondly, the rapping sound has never been knuckles rapping the outside metal. Instead it is the hollow thump of flesh beating against the wood door.

Are the ghosts trying to get in or out?

CHAPTER 4
STAN LEVINE

Walk in or near the Cary House Historic Hotel at 300 Main Street, and there is a good chance a meeting with Stan Levine might take place. Some find the entity encounter thrilling, while others are a bit annoyed.

Stan was said to have two passions while alive. One was drinking alcohol, and the other was flirting with pretty women.

Where Stan is concerned, facts are admittedly sketchy in the usual research locations, like libraries. Most sources agree he was the hotel's front desk clerk in the mid- to late 1800s. Some say his flirtatious nature got him killed when a jealous husband shot him. Others say it was alcohol. Luckily, decades worth of sightings and incidents have instilled him firmly in Placerville's haunted history.

Stan's love of drink led him to spend his off hours at local saloons and cafés during the mid-nineteenth century. By the late twentieth and early twenty-first centuries, bookstores stood where drink had once been served. Mention of books being tossed around by unseen hands grew. Stan's ghost was identified as the responsible feisty spirit, displaying his utter disgust at the lack of spirits, except in printed word form.

Even where alcohol was still served, Stan was known to make his presence known in dramatic fashion.

Until January 2014, when it closed, Synapse Wines' tasting room, physically connected to the Cary House, was the place both staff and patrons experienced Stan. Mitch Foster recalled how the store's computerized cash register and music system were often the favorite targets of mysterious mischief, saying, "Anything electronic fascinates Stan."

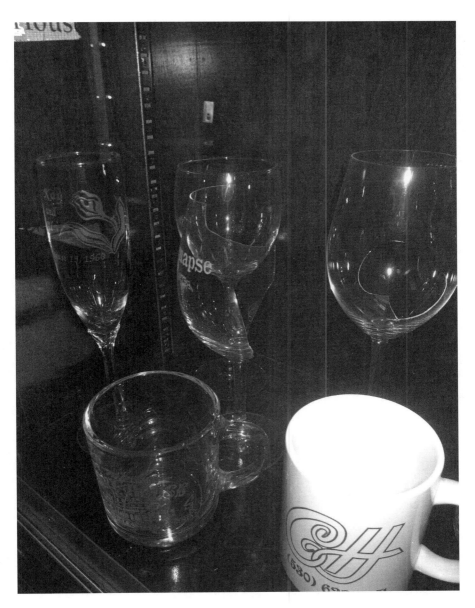

Wine glass broken by Stan Levine.

Regardless of the fact that he supposedly died when U.S. Grant was in the White House, Stan is still smitten with the ladies—especially young vivacious blondes. Several years ago, a pretty Australian tourist by the name

of Emma sat solo along the bar. Her Aussie accent, heard as she told tales of her travels, charmed all who listened but most of all the nineteenth-century ghost. Without human interaction, the music kept getting louder while she spoke. Foster turned the volume down twice. He knew it was Stan's attempt to get Emma's attention. By the third time, the wine seller was annoyed.

"Cut it out," he yelled.

Immediately, the music stopped. Although the computer did not indicate any problems, it failed to work the rest of the evening. Stan had obviously left in a huff. By the next day, all was forgiven on the phantom's part, and music was again playing.

Stan's amorous mood also manifests itself in one undeniable kind of physical contact with the living. He loves to pinch bottoms. It appears he is an equal opportunity pincher, as both pretty women and handsome men have reported their derrieres tweaked while either in or near the hotel lobby. Some claim it also happens in Quartz Alley, bordering the Cary House. A few people on our ghost tours reported the feeling of having their butt cheeks cupped and then given a gentle goose. Others have experienced him on the sidewalk by the hotel's front entrance.

Amy Harris has incurred Stan's slightly lascivious nature. Although a brunette, the Placerville resident's vibrant personality is evident. Bundled up against the chill of a winter's evening in 2014, she crossed Main Street by Quartz Alley. When she got to the front of the hotel, she felt a distinctive hand along her back. It quickly lowered itself until it stopped on her rump.

Stan Levine's hangout in Quartz Alley.

The peculiar encounter ended with a fast squeeze of her right cheek. She might not have thought it strange had her husband been with her, but on that night, Harris was alone in Main Street.

Stan's attempts to impress a one-time pretty female manager manifested itself into a mini windstorm that swept through the shop without the air conditioning working.

Stan's antics at Synapse also included odd orbs traveling at high speeds and three light balls suspended in the air of the main room. Luckily, the shop's security camera caught one of them.

Celtic harpist Anne Roos from South Lake Tahoe was a regular musician at Synapse. After finishing her last set one evening, she was packing up to leave in the back office. Suddenly, the screen of the computer, connected to the surveillance camera, displayed light moving across the empty tasting room. At a height of less than six-feet high, it hovered briefly before disappearing.

Shocked, she called out to Foster. Together, they stared at the computer screen and were not disappointed. Within minutes, another unexplained energized ball of light shot from the bar area to the opposite wall. Peering out into the haunted room, nothing looked amiss. Perhaps Stan had simply demonstrated his sadness that the night's music, laughter and good times had come to an end.

While renowned for his huge appetite for the high life, Stan strongly disapproves of anyone who makes fun of him—even in death. Foster remembered a group of women who entered the wine bar just days after Halloween in 2012. As was often the case, he shared stories of Stan along with glasses of red wine. The women, however, ridiculed Stan and made more than one rude remark at his expense. Then their voices gathered to chant, "Show yourself, show yourself."

Annoyed by the disrespectful mantra, Stan's revenge was quick. One of the cynic's glasses cracked. As wine poured across the bar, everyone noticed it had not cracked in a usual pattern, but instead, half of the glass from the rim down the bowl to the top of the stem had broken away.

Former employee Kathy Benzon recalled a similar incident months later. Four women, staying next door at the Cary House in hopes of having some supernatural experiences, were drinking at a small table. Their wait for an unexplained event was short when a large explosion came from their assorted wine glasses. One of them had also vertically broken.

"Let's just say they were more than a little freaked out," said Benzon.

Recently, new tenants have moved into 304 Main Street. Stan has already indoctrinated them to his presence by messing with their music system.

Old wives' tales warn against whistling inside and after dark. Back at the Cary House, apparently Stan does not adhere to the advice. Jaunty tunes echoing down hallways and in corners have been heard by both guests and staff.

That, like everything else connected to Stan, has been done without the benefit of a body. After invisibly pulling a stunt, a roguish sense of fun lingers in the air.

CHAPTER 5
THE CARY HOUSE HOTEL

Almost since the summer of 1848 when three hopeful Argonauts—William Daylor, Jared Sheldon and Perry McCoon—mined gold in what is now Placerville, there has been a structure on the site of present-day 300 Main Street, which could explain the paranormal beings said to haunt the modern-day Cary House Hotel.

Built out of logs in 1849, the El Dorado Hotel and Saloon was a favored place to celebrate a lucky find or drown hard labor blues for many gold seekers. Following Placerville's devastating mid-1850s fire, the first Cary House grew from the ashes of the El Dorado. Over the next 122 years, as owners changed, so did the hotel's name, from Placerville Hotel to Raffles Hotel and back to the Cary House during the late 1970s.

When the hotel's fourth story was added in the 1920s, much of the construction's funding came from piles of gold dust found in the basement's floorboards. The hotel's porch once stockpiled bags of gold dust and silver ore, respectively, for the Wells Fargo office inside. Some reports say as much as $90 million in nineteenth-century numbers passed across its scarred wooden boards.

Famous people, including Mark Twain and Elvis, slept in its rooms and lived to leave. Others never awoke and continue to make contact with the living.

Stan Levine is one of the Cary House's most famous spooks. So well known is he that he has his own chapter (see Chapter 4).

Other entities usually lurk around the second and third floors. The hotel's firm policy on not allowing non-guests to prowl around upstairs is

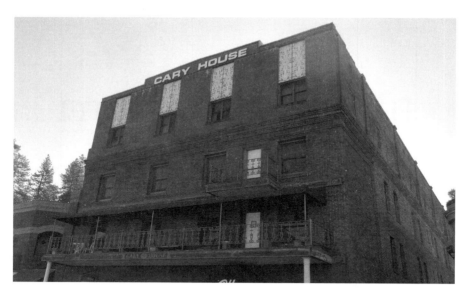

Cary House Hotel.

understandably strictly enforced. The best way to make contact is to book a room. Which room depends on which ghost one wants to encounter.

Room 209 has been reported to be cooler, up to almost fourteen degrees cooler than other rooms, even with the thermostat turned off during the late summer heat of Placerville. Typically, this indicates a spirit's presence absorbing energy.

Next door, according to a front desk employee's 2014 recollection, a nerve-jangling tale originated in room 207. A single woman checked into the room and proceeded to pull out her late father's hand-turned burl wood pen to sign the guest book. Instead of the black ink that normally flowed from its tip, the woman was unsettled as vivid scarlet words streaked across the page. When her second written attempt was as blood red as the first, the guest quickly ran back downstairs with the pen and guest book in hand.

Nearly hysterical, she asked the front desk staff to use the pen and write something—anything. Agreeing to the out-of-the-ordinary request, the employee scrawled something across the page. Both women stared thunderstruck at what was in front of them. Once again, the pen's ink was black. Perhaps the phantom is a woman, as a strong scent of perfume is heavy near the closet.

Directly upstairs in room 307, two women from San Francisco experienced an unsettled night's sleep in late April 2012. All was peaceful in the suite

separated by a door into two bedrooms until one woman was startled awake. Her sleep-clogged brain first deciphered the sounds filling her room as fighting cats. Quickly, she realized it was cries from her friend in the adjoining room. Opening the door, she discovered her friend sound asleep yet calling out her name, along with the phrase "Help me, I am terrified."

After being shaken awake, the second woman stated there had been a man dressed in a plaid shirt lying next to her. She had also been fully aware of her friend's arrival but had been unable to rouse herself.

Room 212 remains the most requested of the hotel's rooms. Supposedly, it is the most haunted. According to the hotel's marketing and publicity manager, Lanny Hardy, a rocking chair under the archway between the front room and bedroom moves inexplicitly as guests have entered the carpeted room. Paranormal teams spending the night have had freshly charged batteries inexplicitly drained to uselessness, heard repeated odd clicking and captured videos of orbs soaring across the room.

The most famous of the room's permanent spirited residents is Arnold Wiedman. First appearing to the public during the Raffles Hotel's period of the twentieth century, he has never been wholly seen. Only boots, jeans and a flannel shirt from the ribcage down have been visible on what psychics have called a teamster from the nineteenth century.

His tale was not a happy one but was typical of the age. Illness, probably influenza, claimed Wiedman while he lived at the hotel. Unfortunately, he left behind a wife and young daughter unable to leave Placerville until money arrived from eastern relatives. When the late Mr. Wiedman's family left California, they never returned—at least, that's how it seemed until the scent of lavender started filling the room.

Maintaining one's personal hygiene could be a challenge in a town where nearby creeks could stop running by early summer. Lavender did and continues to grow lushly in the foothills of the Sierra Nevada. Women of the Victorian age, seeking to mask unpleasant bodily odors, would stick its fragrant sprigs in their hair or down their décolleté or tie it in bouquets around their waists. It has been speculated the sweet overtones circulating in room 212 and just outside in the hallway belong to Mrs. Wiedman. It proves that love survives—even in the afterlife.

Not all the spirited activity happened in the guest rooms. Chris Hodges recalled that during his Cary House tenure, part of his duties included readying the breakfast room. More than once, he would walk into the dark room, flip on the light switch and stand amazed at the disarray illuminated before him.

Unopened packets of cereal were strewn about, as were bananas. Other fruits, like apples and oranges, remained untouched. Nothing ever appeared to be opened or partially consumed. It simply appeared like a ghostly nocturnal food fight had occurred.

Spirits at the Cary House Hotel are available for spooking any time of the day or night.

CHAPTER 6

GHOSTS OF PLACERVILLE'S CHINESE

Few physical reminders exist in Placerville of the Chinese Argonauts who flocked here as early as 1849. At the time, fewer than 60 lived in the entire California territory. In fewer than thirty years, the number statewide had expanded to close to 116,000.

The vast majority of Chinese immigrants were low-paid employees of mining companies. Their ancestral homes, mostly in the Canton province, were in almost constant upheaval due to opium, civil wars and natural disasters.

Unlike other ethnic groups, those early Asian immigrants strove to retain their sense of community during their time in "Gum Shan" or "Gold Mountain," as California was called. A joss house served them as a place to worship, have letters written and find legal help. Chinese, like other non-Americans, had few rights.

But amongst themselves, turmoil could exist. In Placerville's large Chinatown, located in the southwestern part of the city, two joss houses were constructed due to friction between the residents. The latter, built by the See Yap Association at the corner of Pacific and Goldner Streets, was completed in 1872. Several Asian phantom sightings have been experienced along Main Street. One is identified as a murderer who chose suicide instead of the gallows, while the identity of the other or others remain unknown.

Could it have been personal discord that led Ah Soo and Ching Sam to fight to the death on September 19, 1859? Near the present-day Main and Sacramento Streets intersection, the two squared off. Bowie knives were drawn, and a moment later, Ching Sam stood triumphant. One hand held

his knife, while the other clutched the long queue of his opponent. The long ponytail, grown since birth, was considered a thing of honor. In one fast slash of a knife, Soo's dignity was gone. Worse, now disgraced, he was unable to return to his homeland.

Enraged, Soo countered the attack with his own knife thrust. Seconds later, Ching Sam fell down mortally wounded.

Called an "unfortunate wretch" for a "horrid deed in cold blood," Soo's murder trial two months later was swift. Stating that the crime had been committed without provocation, the verdict of murder came after a short deliberation by the jury. Without any consideration to the cultural insult Soo had experienced, he was sentenced to hang within a few days.

However, Ah Soo missed his date at the gallows. He hanged himself in his jail cell. Some remarked that the citizens of El Dorado County should be thankful to him for with his suicide, the shorn-haired Chinese murderer had saved the county the hangman's fee.

Late at night when traffic is almost nil along Main Street and the dampness from winter's rain is high, people have reported seeing a small Asian man in the middle of the road. Crippled from arthritis, his hunched-over frame appears to be searching for something. It is his lost queue, many believe. Ah Soo wants to return home—more than a century and half after his suicide.

Another sighting occurred farther up Main Street. Zia's, a popular gelato place until its closing in January 2014, had many inside spirited encounters with staff and customers. One enigmatic figure even found an audience just beyond the front door. One night after locking up, two male co-workers went in separate directions. One walked east, while the other headed west along Main Street.

Several seconds later, the westbound man was aware of someone rapidly approaching him. Although there was no sound of feet walking on concrete, he knew it was not his fellow employee. The advancing shadow growing bigger on the sidewalk appeared to be a taller woman. Wearing a dress, her hair was fashioned into a long braid that swung back and forth. Feeling he was about to be run over, the man slowed down and stepped to his right to let her pass, but nothing happened. Spinning around, he found himself alone on the empty sidewalk.

After relating his odd encounter to his colleagues, one suggested that the mysterious spirit might not have been a towering female but rather a long-dead Chinese miner with his queue intact. Nineteenth-century author William Perkins described Chinese attire in his book *Three Years Residence in California*: "Petticoat trousers reaching to the knees with big jackets lined

with sheep or dog-skin, and quilted. The lower part of their legs encased in blue cotton stockings, made of cloth and not knit, and are attached to shoes also made of thick cotton cloth, and with soles fully an inch in depth." Combining that information with the fact that the incident had happened just a couple blocks from the heart of old Chinatown, it appeared one of its former occupants was still walking around Placerville.

PLACERVILLE HARDWARE STORE

C reaking wooden boards, held together with square nails, announce your arrival at the oldest continuously operating hardware store, west of the Mississippi. Push past the swinging doors on either the former gentlemen's or women's separate entrances, and the past comfortably collides with the present. Need a hinge for a 1920s pie safe? It can be found in a bin, alongside gold mining equipment across the store from where modern-day culinary equipment helps today's cooks create.

The store has been owned by multiple generations of the same owners. The Fausel family has been a part of Placerville Hardware for over sixty years. This has made them quite familiar with and used to their "entities," as matriarch Deanna calls them. She prefers that description instead of calling them ghosts, spirits or the undead.

She feels they are a positive part of the business and the building. The latter was first constructed in 1852. In the following five years, it had multiple owners until Silas Randall, a brick mason, bought it. Luckily, he pulled down the original wooden building to replace it with a brick structure in the spring of 1856. Just months later, when a fire reduced much of downtown Placerville into a pile of ashes, 441 Main Street was scorched but survived.

When a paranormal research team was called in during the early twenty-first century, two of the most prominent entities team members discovered were women who love to clean the store at night. Their cleaning tools of choice are old-fashioned feather dusters. While these dusters are part of the store's vast inventory, they are no longer used by modern-day employees to

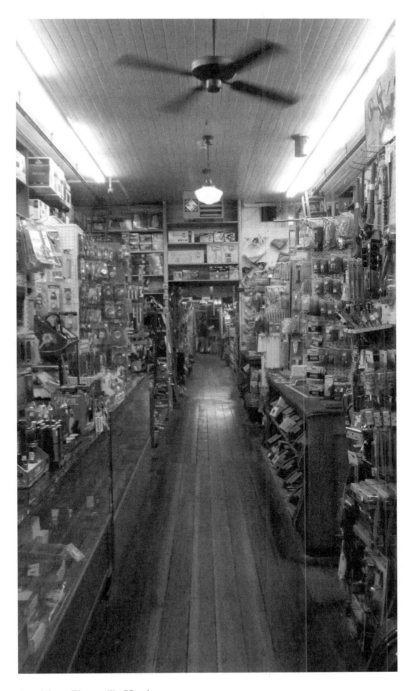

An aisle at Placerville Hardware.

tidy up. Evidence of their existence comes when fluffy bits of feather float down from wooden countertops, the steps of the rolling ladder and items up on high shelves.

It is easy to imagine, between the years of 1852 and 1883, when Placerville's last hanging was held, that when someone yelled "git a rope," they came running to this store. Ropes of varying thicknesses are still found in a back area.

Also found in the downstairs back area is the occasional smell of cigarette smoke. According to family lore, says Albert, Deanna's son and current manager, someone died from an accidental fire. Evidently, whoever the unknown victim was, he has not learned from his error, nor is he aware of California's anti-smoking laws.

Cross the store and by the west side, there is a cold spot. Some might scoff, but I have felt it. During our holiday "Ho Ho Boo" tour, Albert and Deanna graciously invited us on a guided tour of Placerville Hardware. While they spoke, I stood near it. It was strong enough to cut through two pairs of socks, tights, leggings and thick leather boots.

Downstairs is not the only place to feel the presence of those long departed. We trod up the centuries-old back stairs. Their age was evident by the different sets of bricks lining the stairwell. On the second floor is a stock room. At least half the length of the store, shelves are stacked to the ceiling with merchandise and memories of old. Ledger books dating back to the turn of the twentieth century offer insight into the lives of past Placerville residents.

Also found in two areas were more cold spots. Deanna told us about the energizing power of one. Standing in its midst, some claimed to feel unseen hands on their shoulders. Others felt a force attempting to push them backward. I felt a vibration.

On the western side was where the *Mountain Democrat*, California's oldest newspaper, was once housed. Now it is where gifts are wrapped, the staff takes a break and apparitions appear. Several times, Albert has crossed the threshold to find a misty figure there. Its dark and opaque appearance has never materialized into a clear image, but it has left a lasting impression on Albert.

I did not see anything misty, but after descending the staircase psychics have identified as a spirits' portal, I was treated to the final supernatural treat at Placerville Hardware. One entity is a known prankster. He or she loves to untie employees', especially women's, shoelaces. This occurs so often that several women have resorted to wearing clogs, boots or buckled footwear.

Placerville Hardware's stairwell portal.

As we left the store to continue the ghost tour, I realized my left boot was untied. Considering that its lace had been triple-tied, a sense of amazement and pride flooded me.

I had been pranked by one of Placerville's most mischievous entities.

CHAPTER 8
HANGTOWN'S FIRST HANGING

Its present state is shrouded in scaffolding, and its future is unknown. Yet the history of 301–305 Main Street is among the richest in not only Placerville but also the entire county.

On this land by a ravine once grew a white oak tree. In a region where such trees grew abundantly, it was larger than others. It offered much-needed shade to both man and beast at Elstner's Hay Yard during the blistering summer heat. Beginning in 1849, its lower boughs supplied the sturdy base for the hanging of scoundrels, robbers and murderers of the early gold rush days. Overnight, the one-time town of Dry Diggings received the lasting moniker of Hangtown.

As it was the final earthly destination for the lives of several violent men, it has its own haunted tales among the many Mother Lode stories. Most were gathered during the time of the Hangman's Tree Bar, which stopped operations in 2008. All stem from a time when vigilantes delivered western justice with a noose.

History shows it all began less than a year from James Marshall's epic discovery of gold. At this time, a gambler by the name of Lopez arrived with a large vial of gold dust. Wanting to increase his money, he walked into the El Dorado Saloon and Hotel, now the site of the Cary House Hotel. Lady Luck was by his side that evening of January 19, 1849.

The more he won, the more he drank, and the more he drank, the more he talked about his winnings. Soon everyone present knew how much money the gambler had. Several hours later, he retired to his upstairs' room. He

was not alone. Five men followed him with the sole intention of separating Lopez from his loot. One held a gun to his head, while another ransacked his luggage as the other three tried to bar the door.

Then noise of the scuffle reached the gambling floor. Chairs scrapped along the wooden floor, and the staircase bounced from the dozens of boot-shod feet flying up it to see what was happening. Yanked off the out-numbered gambler, the assailants were quickly hustled back to the bar area.

Their limited English skills, coupled with swarthy complexions, told the crowd these were not Anglo miners. That was far from unusual in this small geographic area crammed with nationals from around the globe.

Justice was swift as a jury of twelve men was quickly chosen. In front of a judge, the facts were presented, and the sentence was equally fast. A punishment of thirty-nine lashes was pronounced and due to take place the next morning.

Eyewitness accounts reveal that a crowd of nearly two hundred gathered at Elstner's Hay Yard, directly across from the El Dorado Saloon, to watch the floggings. Lashed to the trees, the bandits' bare backs transformed into raw and bloody messes after several swipes of the thin strips of leather. Following the administration of their punishment, they began to be dragged unconscious or nearly there to a nearby house.

However, as the crowd caught a better look at the criminals, a roar erupted. Three of the five were recognized for theft and attempted murder of miners down at the Stanislaus River gold camps. An abrupt change in atmosphere occurred.

Within minutes, a new jury, temporary judge and trial was in progress outdoors. The accused, now identified as Garcia and Bissi, both French, and Manuel, a native of Chile, never heard the charges brought against them or had a chance to state their case. They remained bleeding and woozy across Main Street.

Following the thirty-minute trial, recorded as lacking in real facts, the judge asked the mob, fueled by alcohol, if guilt had been established. The resounding cry of "yes" led to the next question.

"What punishment shall be inflicted?" he asked.

The lone suggestion of "hang them" swelled as the cry repeated itself through the throng.

Several protested, however, including E.G. Buffum. His firsthand account stated that he jumped onto a tree stump in the hopes of finding respect for the law and compassion. Instead, the chance to join the convicted men with his own noose was offered.

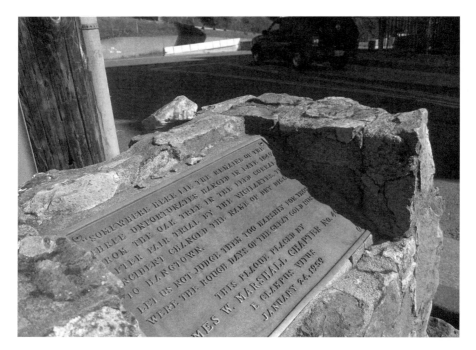

Memorial to Hangtown's First Hanged.

Willing feet went running for thick ropes, as equally keen hands dragged the guilty trio into the hay yard. Desperate pleas in their native tongues failed to be understood or alter the crowd's vigilante spirit.

Placed into a wagon, adorned with a noose and blindfolded with black handkerchiefs, Garcia, Bissi and Manuel were hanged. When dead, their bodies were cut down, wrapped in their blankets and buried at what is now the corner of Highway 50 and Center Street. Their bodies remain there under a flagstone marker surrounded by electrical boxes.

The restaurant next door to this location has had several incidents of flying dishes and wine glasses and angry garbled voices. Today, many think the ghostly trio are the culprits.

After several years, the hanging tree was cut down by the neighboring Jackass Inn's owner Bruce Herrick, who wanted to expand his business, which required taking over the former feed lot. Soon another building that shared a common wall graced Main Street.

The public outcry was enormous, driven in part by the following poem appearing in the local newspaper.

Herrick, spare that tree!
Let not its branches fall;
Here let it always be
A warning to us all.

For it was in forty nine,
When our good town yet was young,
Three men for murder vile
Upon that tree were hung.
Yes, on this same old tree
These miscreants met their doom;
Keep it for all to see—
As a grave-tree o'er their tomb.

This tree let always stand!
For 'tis of great renown;
Then, Herrick, Stay thy hand;
Spare this relic of our town.

Over the years, a popular topic of conversation has been whether or not a section of the infamous hanging tree's stump existed in the building as late as 2013. Former owner Ruby Decair admitted in a 1995 newspaper interview that a contractor had told her it was still in the basement. Others say it was under the jukebox of the old bar. Another group contends that the tree was completely taken out just before World War I.

The number of differing opinions are reflected by the varying views on the two buildings' sets of specters. Current owners Tim and Sue Taylor deny any supernatural happenings as they complete a major renovation of the two buildings. Others, also intimately connected to 301–305 Main Street, have their own stories.

Ghostly cries were heard, supposedly from the tortured souls who met their end wearing rope neckties. Lifelong resident Jami Angi recalled Decair saying she would sometimes encounter a ghostly man dressed in the typical attire of a nineteenth-century miner seated at the bar when she would first enter. Before she could ask anything, he would disappear into a mist. Unexplained green lights have glowed from the basement. Some say it is the spirits of those who assisted the hangman in the various executions held on the hay yard's large tree.

Back in the heyday of the Hangman's Tree Bar's popularity, women would report feeling uneasy while in the ladies room. A ghostly man, dressed head

to toe all in black, also was seen walking out of the same restroom. Was it the spirit of Darrell, the one-time hangman who lives up Main Street at the chamber of commerce building but has been witnessed wandering between 524 to 305 Main Street? One woman even momentarily saw an old man's reflection directly behind her in the mirror at the bar.

As in many places in Placerville, phantoms at this location are fascinated by the convenience of modern-day plumbing. Perhaps they remember the lack of water during the gold rush's beginning when the city was called Dry Diggings.

CHAPTER 9
IRISH DICK

A long Placerville's Main Street once roamed violent men. Here is the story of one.

Not everyone who flocked to the Mother Lode territory of California had a pick and shovel in his hands. The lack of essential mining materials, however, did not diminish the thirst for gold. These men just had other ways of obtaining it.

Richard Crone was a gambler, born in Ireland, who possessed a sense of adventure and a lack of morals. No records exist as to when he arrived in the United States or how exactly he traveled to the West Coast. Young and barely out of his teens, his favored game of chance was three-card monte. Aboard the steamships between San Francisco and Sacramento, he perfected his craft on eager Argonauts and disillusioned ones desperate for at least one win. Few ever won.

Those who chose to question Crone's honesty soon found themselves in a fight. Aside from duping unsuspecting miners, the Irishman, extremely short in stature, loved to use his fists. His pugnacious ways gave him the nickname of "Irish Dick."

Settling in the burgeoning town of Dry Diggins, known better as Hangtown, Crone soon was cheating Eldorado Saloon regulars from his own table. Now the site of the Cary House Hotel on Main Street, the Eldorado offered action of all sorts, day and night.

It was on such a night in October 1850 when Crone's temper and brutality coupled to spell disaster. Autumn's cool breezes were felt by all with the

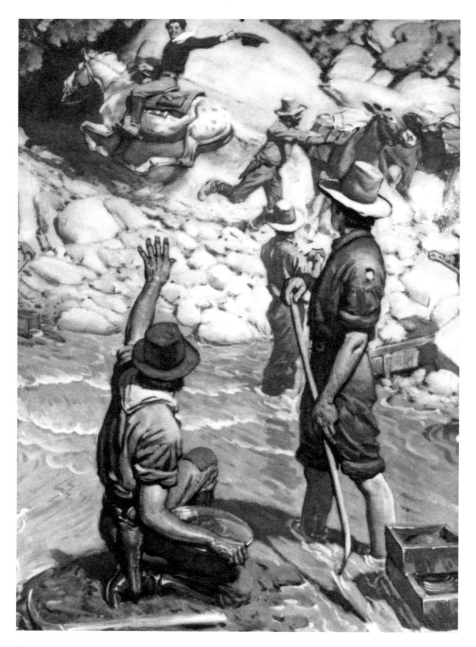

Prospectors Panning Gold. Painting by Harold Von Schmidt. *Courtesy of California State Parks, 2014.*

constant opening and closing of the saloon's front doors. Inside the smoke-filled interior, Crone was holding court when a lone figure filled the doorway. Barely a flicker of recognition crossed over the gambler's face when suddenly cards, coins and vials of gold flew from the table as he jumped over it with a knife in his hand.

The knife found its target in the chest of the man who had just entered. As blood oozed across the warped wooden flooring, the man died quickly.

Stunned into silence, the saloon's crowd watched while Irish Dick bent over to pull the knife from the still-warm body, wiped its blade clean and strolled toward the door. There he stopped, turned back to the body and realized the corpse was actually not the man he had thought it was. With cool disregard over just another dead miner, he continued out into the night.

However, this dead miner had a brother working the nearby Chili Bar mine. Men on fast horses delivered the tragic news to him and other miners from surrounding camps. The bereaved sibling kept repeating one expression: "Hang Irish Dick." Across the foothills, the phrase gained momentum as dozens and then hundreds of onlookers yelled it while gathering around the oak tree in Elstner's Hay Yard.

With a jury quickly chosen, Crone accepted his inevitable fate and even offered to assist the hangman in his unenviable task. In an unwavering brogue, he said if given the rope he would gladly climb to the tree's highest branch. Then after tying a noose around his neck, he would dive, headfirst, to his death. Fearing to set a bad precedent for future hangings, the hangman refused Irish Dick's offer. By 2:00 p.m., as the *Mountain Democrat* newspaper reported, the gambler and killer was launched into eternity.

While the murderer's body was committed to the ground in an unknown grave, his spirit still lurks around downtown Placerville. Until 2008, a bar occupied the site where the tree once stood. There are mysterious mists said to leave the building and try to ensnare unsuspecting motorists, and Irish Dick is said to be one of them. He has also been seen on the second-floor balcony of the Cary House Hotel with a deck of cards in his hand. Situated where the El Dorado Saloon once was located, it appears the cheating gambler is on the lookout for his next patsy.

CHAPTER 10

A MOTHER'S
EVERLASTING LOVE

I t is not known if Alabama-born James Page was close to his mother, Frances, as a child. What is known is that she was with him until the end of his days, which occurred at the end of a rope.

Placerville's reign as "Hangtown" was quickly drawing to a close in 1883. The newly opened Folsom Prison, twenty-five miles west, was now being used to carry out the death sentences of convicted prisoners. City officials had received notice from the state to close down the local gallows.

Although refined residents were undoubtedly glad to have the coarse and violent chapter in the city's history draw to a close, many in town, especially local business owners, were not. A hanging in Hangtown meant an increase in business as macabre mobs filled saloons, hotels and restaurants.

The end of hangings in Hangtown did not come soon enough for James Page. August 10, 1883, dawned hot and dry. In his jail cell, Page sat alone and heard the crowds gathering early to ensure best seating. His execution was set for 8:15 a.m.

By all accounts, Page was a man with few virtues. Born in 1844, his nastiness was well known in the area. At an 1870s community dance, he had, as a vicious joke, added poisonous oil into friends' coffee, which killed them. He was convicted and sentenced to time in the state prison at San Quentin.

His murderous streak continued with a deadly assault against a man near the El Dorado and Sacramento county line in early May 1883. A drunken Page was observed speaking with a stranger. His identity was unknown, but

his prosperity was confirmed by the bills in his purse and the twenty-dollar bill with which he paid for a bottle of wine.

When warned of Page's violent nature, the man hurried away. However, the ex-con soon overtook him. Shortly after, five rifle shots rang out. The severity and brutality of the attack stunned all who witnessed the aftermath and heard the details during the trial and beyond.

The unknown victim, described as middle-aged with a quiet demeanor, was presumed to be a miner due to the pickaxe, shovel and other excavating items found on his horse. Shot in the head and having a broken left arm, it was evident he had put up a fight before having his skull crushed with multiple blows from the butt of a gun. Not satisfied with just killing the man, Page's murderous fury turned to the victim's dark bay with a star pattern on its forehead. Shot four times, the mare's throat was nicked, leaving nearby foliage drenched in its blood.

The jury's deliberation was swift. Minutes before he was to be led to the gallows behind the courthouse, his cell door swung open. Stepping inside was his mother, another relative and not one but two local ministers.

With desperation in her voice, the sixty-year-old pleaded with her son to ask for forgiveness and accept the Lord. Yet even with death so close, Page remained unrepentant as he ordered all, including his near hysterical mother, out. His stoniness remained as he walked to his fate with a county deputy on either side. The measured cadence of his steps matched the rhythm of the sheriff's voice as he read the death warrant behind him.

Murmurs of disappointment increased through the crowd as the emotionless murderer passed by. Where was the show they expected for Placerville's last public hanging? In a few minutes, they received what they came for.

Standing on the trapdoor, Page began to tremble. His escalated shaking caused the sheriff to ask if there was a problem.

"I need a drink," was the killer's shaky response.

The sheriff ordered water, to which Page interjected a preference for whiskey. Forced to be satisfied with water, he drank his fill and was again placed over the trapdoor of the gallows. With the noose cutting into his neck, a hood covered Page's eyes, blocking forever his view of the world.

Suddenly, he dropped. A collective gasp escaped from the spectators. James Page had not been hanged; instead, he had fainted. Perhaps he thought this would delay the inevitable. Luckily, the strong arms of El Dorado County lawmen picked him up and for the third time positioned him atop the trapdoor. With the pull of a lever, there was a thud, and James Page's dead body spun round and round.

Cheers erupted. Yet over the din a thin reedy voice could be heard: "Oh please pray for my son, and have pity on me."

Dressed in mourning clothes, Frances Ralston Page was supported by family members while she cried out those words. It would not be the last time they would be heard.

Almost twenty years to the day after her son's execution, she died in Sacramento. That fact has not stopped her from revisiting Placerville repeatedly. She is sometimes seen, a huddled, wispy little figure all in black, in two spots on Main Street. One is near the former Hangman's Tree Bar at number 305. The other is at the bottom of the outside steps of Placerville's former city hall situated next to the courthouse. Perhaps in death she attempts to do what she could not achieve in life: to be a good influence on her wayward child.

As to James Page, he is said to be part of the collected group of spirits that once resided in the saloon, closed in 2008. Now their periodic escapes into present-day lives come in the form of mists in the middle of the night that envelope lone cars cruising up and down Main Street.

Even from beyond the grave, Page's cruelty extends to others.

CHAPTER 11
MEMORY CHAPEL

H ow many of us have followed a childhood dream to success as an adult? George Olson knew young what his future occupation would be. As a young boy growing up in Kansas, he announced his intention to become a mortician and own a mortuary.

After serving in the U.S. Navy during World War II, a move to Southern California allowed him to begin his career as a mortician. Among the many funerals he assisted with was that of Academy Award–winning actor Charles Laughton, who had portrayed the *Hunchback of Notre Dame* in 1939.

By 1978, Olson's long-held dream of owning a funeral parlor came true when he purchased Memory Chapel in Placerville, at the corner of Bee Street and Highway 49.

Yet less than twenty years later, Olson confided to his colleague Tom Carroll that he wanted to sell Memory Chapel—fast. Carroll, then a Placerville police officer, had known the mortician professionally for the entire time Olson had been in business in the El Dorado county seat. His statement had greatly surprised Carroll. Aside from handling a large number of the area's funerals, Olson and his staff had also performed autopsies for local law authorities. Memory Chapel held a solid reputation as a successful business in Placerville.

When questioned for his reason to quit something he obviously had such a passion for, Olson hesitated briefly. Then he admitted something amazing and, for many, unbelievable.

Memory Chapel.

Late at night, before retiring to his upstairs' apartment, he would walk around the chapel, turning off lights and locking windows and doors. Coffins housing the recently dead usually were in one or both of the two parlors. Increasingly, Olson would feel the need to return to the darkened rooms.

There, hovering just above and around the coffins were mist-like spirits of the dead. Their numbers ranged from just a few to a horrifying multitude.

Most shocking to the funeral director was the occasion when he reentered a room where a baby lay in its tiny casket. Several ghostly apparitions, including that of an infant, floated near it. Was it the soul of the dead infant whose earthly body lay below enveloped in silken cloth or another child who had once been laid out in the same place?

Too terrified to enter the room fully, Olson never discovered the answer.

George Olson was not a man ever described as hysterical or crazy. Highly respected for his civic activities, he served as a president of the local Lions Club and the El Dorado County Chamber of Commerce.

Yet questions remained. What attracted the spirits? Were they a welcoming committee to another world or stuck in the old one and attempting to get out?

Olson was not the only one to experience strangeness. In the early twenty-first century, Melissa Arcona worked for a local florist. Delivering floral arrangements to funeral parlors, often where the dead were laid out, was part of her job.

She said, "It was only at Memory Chapel that I got the creeps. I always felt someone or something was watching me—and not in a good way."

The chapel's past history, before Olson's purchase, is fairly brief, according to Placerville native and local historical enthusiast Mary Ann Schroth. She recalled it being built in 1936. Dedicated to the region's pioneer mothers and fathers, the chapel's September 4 opening was a major news event with a full-page newspaper supplement. Schroth could not remember any building, commercial or residential, residing on the property prior to that.

A search through the city's nineteenth-century maps only uncovered a P.H. Teare who owned the land in 1872. It is not known if Teare was a man or woman, so the story ended there.

Could it be the actual physical location that invited specters into the now-closed funeral parlor?

Directly across Bee Street in a hilly section of Placerville Union Cemetery is where infants and children slumber in eternal sleep. They are among the six thousand plots of people buried there since 1871. Chances are good that the land, like much of the area, once held unmarked graves of gold rush hopefuls who dug into the earth looking for riches. Instead, illnesses like cholera, influenza and depression found them.

For at least nine years now, Memory Chapel has been boarded up and for sale. Walk past or sit for a bit in its abandoned parking lot, and soon a sense of melancholia sweeps over.

One can almost hear the silent screams of the departed trapped inside.

CHAPTER 12
LOFTY LOU'S

Mary Lou Anderson knows quite a bit about dyeing. For decades, she has honed her skills as a textile artisan. Her Lofty Lou's Yarn Shop has been a mainstay for over twenty years along upper Main Street.

Filled with a diverse array of fibers in many hues, tones and textures, the building's history is as colorful as the store's merchandise. Over the past three centuries, few exterior changes have been made to the store originally built as a house at number 585. It was constructed when silver from the fabled Comstock Lode came across the Sierra Nevada. Its arrival kept Placerville rich as immense wealth from gold mining petered out in the mid- to late 1850s. Used as a residence for decades, some of the building's past residents still remain.

A few years ago, Anderson was approached by a psychic. She was told the spirit of a young girl resided in the building. Without any previous encounters with the supernatural, Anderson was curious to hear more.

"You must take care of her," said the medium.

Admittedly, the command made Anderson nervous. She did not want the responsibility of beyond-the-grave babysitting.

Her live-in spook has also manifested itself to animals. Some say our four-legged friends possess a special connection with the spirit world. Anderson would agree after witnessing a customer's small dog as he barked incessantly at something unseen. Standing in the house's former parlor, now filled with yarns, looms and other supplies, the frenetic dog could not be coaxed into the adjoining room where his invisible tormentor was.

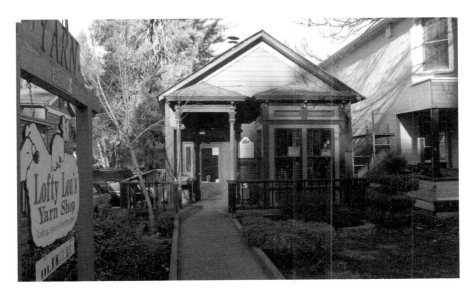

Lofty Lou's.

Questions arose about the room, which was once used as a bedroom. Had someone, perhaps the aforementioned young girl, died there?

Whatever or whoever spooked the dog obviously had moved to another section of the building or made friends with him. Upon the canine's return visit several weeks later, he happily moved around the entire shop without any spiritual stress.

CHAPTER 13

CHAMBER OF COMMERCE BUILDING

Sooner or later, almost everyone from county residents and business owners come to 542 Main Street in Placerville. The 1923-era building, designed in the French Renaissance architectural style, houses the El Dorado County's Chamber of Commerce, the visitors' authority and the film commission office. It is also home to several unexplained entities.

Before it became county property during the late 1960s, it was the Veteran's or old American Legion building for over forty years. Even earlier in the city's history, it had been a rumored site of one of Hangtown's hanging trees. Local legend says that at 524 Main Street, the hanging tree's trunk was where the current building's stairs are located near the front entrance. The sturdy branch, favored for the hangings, supposedly was situated across several modern-day offices on the east side. One office in particular is where current and former employees have reported feeling their energy drained or experiencing a loss of breath when trying to speak. It is the office with a high window and wooden beams crossing the ceiling. Linda Hopkins once occupied it. Hopkins's ghostly run-ins were numerous.

Whether she was the first person in the office at night or the last one to leave after dark, a sense of foreboding periodically overcame her. She said, "I felt a presence of something heavy and uncomfortable."

During an afterhours meeting, one man told her that even when she was physically alone in the building, she was never alone in spirit. Her normal lightheartedness and happy sense of humor were much appreciated by

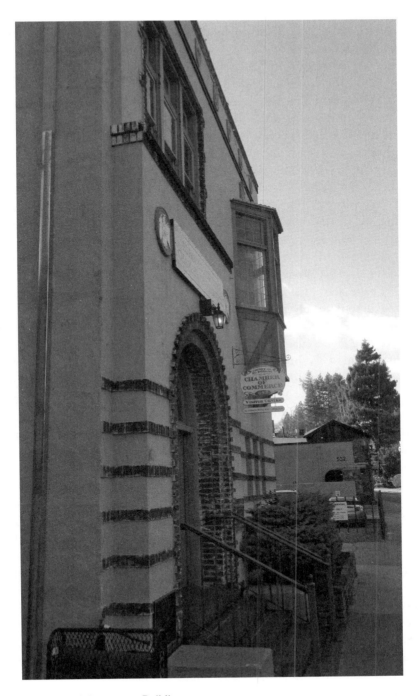

Chamber of Commerce Building.

those on the other side. That is why they congregated in her office, despite giving off negative energy.

"They are watching you," the same man told her.

The following comment perked her interest: "They did not push you." Once, despite multiple trips up and down the staircase previously, Hopkins had taken a short tumble from the top step. The office joke for a short while became how she had been pushed by the ghosts.

Now, three years later, the almost forgotten incident was once again being talked about by someone who had not been present. Hopkins was told that the spirits had, in fact, tried to stop her from falling. When that had failed, they protected her from further injury by shortening her plummet. Accompanying the tales of protection was a description of the strongest entity: an elderly gentleman often in the company of others.

Hopkins, armed with this new information, relaxed more in the building. Whenever she was alone and felt uncomfortable, she would simply state out loud her estimated time of departure and tell the spirits they could have the building all to themselves when she had left.

Another odd happening occurred when a psychic in Folsom, twenty-five miles west of Placerville, told her he was seeing her standing by a large oak tree. From one of its sturdiest branches hung a rope—shaped into a noose.

That account of swinging times and others comes from one of 542's most recognizable residents. Darrell has been identified as a former hangman from the times when western justice was settled with a rope. Described as older and tall, gaunt and wearing a small goatee beard, his clothing is black, as is his stovetop hat, similar to the one worn by Abraham Lincoln.

Many have reported seeing him quietly observing the comings and goings of Placerville from his perch: a second-story bay window with a stained-glass pane. Death has not kept Darrell from being a traveling man. During the early hours after midnight, especially when cold winter rains cover Main Street, his lanky figure has been seen. Usually, his route has been to and from the Herrick Building, where the more infamous hanging tree once stood. His lanky frame has also been seen peering into the bakery across the street before dawn.

Early in 2014, a woman on our weekly downtown ghost tour became excitable as descriptions of Darrell grew. "I saw him the other day," she proclaimed.

Walking after dark along Main Street, she was about to cross Cedar Ravine Street by the Druid Monument when an older male came toward her. There was something odd about him, from his clearly vintage outfit to the white almost transparency of his face. Despite her friendly greeting, the

Ladies restroom at chamber of commerce building.

man passed her without speaking. He did, however, make a lasting sound. He wheezed.

Darrell was asthmatic.

It was the same sound I heard almost five years earlier. Following a meeting in the upstairs conference room, I went to the ladies' room. The room is broken into two sections. One has an antique dressing table, where I placed my purse.

Upon leaving, I took two steps before realizing I had left behind my handbag. Turning around, I was stunned to have the door shut in my face. It was especially surprising since the door opened to an alcove off the main floor. The window in the restroom was closed, and there was no air-conditioning vent.

My attempts to turn the door handle were futile. It simply repeatedly jiggled in my hand. I felt a dense coldness, unlike central air, at my back. More annoyed than frightened, my mood quickly changed when a fast, low gasping intake of air sounded near my right ear. I knew I wasn't alone, and whoever was close to me was not human—at least not anymore.

Almost simultaneously, the doorknob yielded to my frantic turning. Grabbing my purse, I quickly headed to the stairs, all the time being

surrounded by an odd coldness and the sense I was being watched. Unexplained coldness, according to many paranormal experts, indicates an unhappy entity.

Upon reaching the downstairs' offices, I inquired if there was something different in the building.

"Different how?" was the question to my question. After explaining my recent encounter, I was told the building was reportedly haunted.

Others have also encountered Darrell, as I discovered years later. Tom Carroll, a retired Placerville policeman, reported being on morning patrol in 1976 when a call from dispatch sent him hurrying to the chamber of commerce office. Two hysterical women waited on the sidewalk as his squad car pulled to the curb. Their shocked and tear-stained faces bore witness to the extreme fright they had just encountered.

They told of walking up the outside stairs and unlocking the front door. Once inside, a strange noise made them look up. Bending over the second-floor balcony was a towering scrawny man with unnatural skin tone and wearing all black clothing. The gesturing of his bony hand was accompanied by the uneven rhythm of gasps for breath.

Carroll entered the building to validate their claims, but the intense search that followed turned up nothing.

Years later, the installation of a new heating and air-conditioning system required the dropping of the first-floor ceiling and removal of the upstairs' balcony. The reconstruction did not scare the hangman or other spirits away. They are still around.

Jamie Angi is a proud Placerville native. Working part-time at the chamber, her own interest in the supernatural almost equals her pursuit of local history. She accepts the restlessness of the spirits, especially those from the gold rush era. Many of their nineteenth-century deaths were sudden and tragic, unexplained, unrecorded or a combination of events.

While she refuses to be consumed by her curiosity in the unexplained, she often records odd happenings at 542 Main Street. Scribbled notes on bits of paper map out the encounters.

A ghost-like man in green overalls was observed walking around upstairs in February 2013 by a staff member's twenty-year-old daughter. So upsetting was the incident that the young woman still refuses to go upstairs unaccompanied.

On March 11, 2011, during an otherwise normal Wednesday workday, the eyes of staff members suddenly were riveted to the ceiling. From the

unoccupied upstairs, the clunking sound of boots walking across wooden floors was heard. Quickly darting up the stairwell, Angi failed to locate the heavy footwear's owner or identify him. However, she admits whether it is Darrell or another male entity, his mischievous streak reveals itself when it comes to cleaning the men's restroom.

Several times, the swinging door leading to the toilet has been found bolted shut—from the inside.

Finding it mildly annoying, Angi decided to confront her ghost about the provoking habits when an investigation team was having little success with communication. She said, "Are you the gentleman who interacts with me when I clean on Saturdays?"

Electromagnetic equipment, silent until that question was voiced, suddenly blipped and bleeped in a positive response. As recently as October 26, 2013, other visiting psychics reported feeling chills and numbness simultaneously when near the men's restroom.

The late office cat, Mason, also had luck in finding the spirits. Allowed to wander the entire building on Saturdays, the cat would stop midway on the stairs. Before continuing up, he would mew repeatedly, as if calling to an unseen person. Apparently, an answer came, and Mason would disappear for hours.

Other times, the specter-friendly feline found happiness downstairs. Rolling around on his back and purring, he acted as cats do when having their bellies rubbed and chins stroked. The only abnormal thing was that no human hand was doing the petting.

In addition to these experiences, Angi has also heard disembodied voices and a man's laughter and seen mysterious orbs. Sometimes she acts as the building's unofficial ambassador to investigative paranormal teams.

Recent searches upped the number of the building's undead residents. Although they have not been identified clearly by name, they have revealed themselves in other ways. Recordings have captured voices speaking in French, Russian and English with a Scottish accent toward the back of the building, where a stage stood during its veterans' hall uses. They all speak about five graves. Nothing in historical research has uncovered where the graves are located. Sometimes garbled names have also been recorded. They include Ben, Danny, Richard and Billy, in addition to Ann.

Paranormal experts declared the presence of influential men, mostly from the World War II era, having a party. With them were paid female companions, a continuing practice at some private Placerville soirees since the heady days of the early gold rush.

Perhaps one paranormal party became too raucous. When the chamber staff entered one morning, they were stunned to discover several large photos and posters laying in a broken heap by the door. Not only had they been bolted into the solid rock wall, the sharp shards of shattered glass all pointed upward. Was it a warning to the living not to seek answers as to the identity of the party guests? Some think so. Many descendants of the once powerful politicians and civic leaders still live in the area. They might be unaware of their forefathers' nefarious actions or wish to keep them a long-hidden secret.

A word of warning to anyone who views 524 Main Street's south side at night: nocturnal ghost hunters are startled sometimes to see several pairs of glowing eyes from the hillside behind the building. Unfortunately, they do not belong to entities but rather to a small herd of whitetail deer.

CHAPTER 14
MOLLY OF THE FOUNTAIN-TALLMAN BUILDING

The old stone building, situated where Main Street curves up from the Bedford Avenue intersection, fits a Hollywood script's description of a haunted location. Yet the Fountain-Tallman Soda Works, built in 1852, was a literal lifesaver.

After a hot day laboring for riches, many a miner fancied a cool drink of water. Unfortunately, whatever water flowed from Hangman's Creek or other small streams was undrinkable, as it was heavily polluted from the mining.

The Soda Works offered bottled clean spring water infused with carbonate and often flavored with locally grown apple, pear and grape juices. Constructed of locally quarried stones and bricks similar to those found at the Herrick Building, where the infamous hanging tree once stood, the centuries-old structure is a survivor. Throughout each of Placerville's devastating nineteenth- and early twentieth-century fires, she emerged sooty but largely unscathed. An array of businesses used the building until it became a museum in the early 1980s. Now 524 Main Street celebrates El Dorado County history with interesting displays and exhibits. Artifacts, many donated from families with roots dating back to the pioneer era, range from locally extracted gold to vintage flags and household items like washing machines with manual scrub boards.

Paranormal experts claim past owners can attach themselves to past belongings. Could any of the hundreds of items held within the two-foot stone walls still be possessed?

Some claim the building is not haunted by ghosts but is indeed spirited. Local resident Robert Oliver, his wife and I were walking through downtown Placerville just past 8:00 p.m. on January 23, 2014. Oliver is a scryer, making him metaphysically conscious of orbs, auras and flashes of lights most of us miss. Passing the Fountain-Tallman museum, he suddenly stopped me as he took a photo with a simple digital camera. Moments later, a colorful orb appeared just below the museum's street sign.

A further indication of the fondness of entities to stick around the preserved past happened to George W. Peabody, a much-respected historian and author of several books on El Dorado County. Now in his mid-nineties, he continues to write down his observations on life. Annually, for over a quarter of a century he has self-published *The Poetic License of George W. Peabody.*

In the 2008 edition, one chapter entitled "Molly and Me" described his unusual encounter. On June 9, 2007, downtown Placerville was in full-out party mode with the weekend's Founder's Day celebration. Part of the festivities always include the arrival of the Highway 50 Association Wagon Train after a week of crossing the Sierra Nevada.

Unfortunately, Peabody was not able to enjoy it. He was locked inside the Fountain-Tallman museum. As he was up on the second floor, quietly looking at the exhibits, the building had been closed without his notice. Now surrounded by darkness and without a cellphone, he carefully made his way downstairs. Locating an antique chair, he slowly lowered to contemplate the situation. Being that the night was Saturday and the museum was not scheduled to reopen until the following Wednesday, his concern was understandable. With the constant chatter of passing people just outside the building, he wondered how to attract their attention.

Staring into the murkiness, a silent message, neither recognizable as female or male, broke into the historian's thoughts of escape: "Stop staring, you're making me nervous."

As if the entity knew of Peabody's predicament, its next instruction was just as soundless and mysterious yet clear and easy to follow: "Search the door for your escape."

Walking over to the sturdy, sealed door, Peabody's eyes rested on the brass mail slot at the same height as his knees. His escape route became clear. After wiggling his fingers through the slot, two young girls, struck at the odd sight, saw them. Following his instructions yelled through the slot, they soon arrived with a key-bearing docent. Once freed, the docent casually remarked on a ghost named Molly, known to haunt the Fountain-Tallman.

Without any further information handy, Peabody and other visitors are left to wonder if the mysterious Molly lived and possibly died in the building during its gold rush beginnings. Perhaps, a once loved item of hers rests among the museum's vast inventory of items. A suggestion for any future visitors is to find a quiet spot, close your eyes and just listen.

CHAPTER 15
PENNIES AT 312 MAIN STREET

D rinking alcohol in nineteenth-century Placerville dulled many aches from physical labor, unrequited love or loneliness from missing family and friends thousands of miles away.

Just two years after gold's 1848 discovery in nearby Coloma, 312 Main Street was the site of the Adelphi Saloon and Ten-Pin Bowling Alley. Beer was a popular drink for those who hung around to watch one another or witness the occasional outlaw hanging at the oak tree directly across the street.

The frothy brew was also key, 159 years later, to the first supernatural incident at Zia's. The gelato shop stood on the site of the former saloon from 2009 until 2014.

The occurrence was fast and furious, according to J.T. Dougherty, a Zia's barista. While speaking to another employee across the room, he leaned slightly against the counter. Suddenly, from a display of six beer bottles to his side, one flew across the other five and smashed in glassy bits against the kitchen door. Dismayed at the mishap he thought he caused, Dougherty faced the shocked eyes of his coworker. In almost disbelief, she described how, without any human contact, the bottle had levitated itself and flown three feet until ending up in shards of wet glass.

Despite their efforts to replicate the incident by leaning and pushing on the counter, the remaining beer bottles never took flight. Chalking the episode up to a freak accident, Dougherty gave it little thought until the next unexplained event happened a few weeks later.

Stairwell of 312 Main Street.

Again, he and the same co-worker were working the same shift. Each stood at opposite ends of the food display cases and chatted to a customer standing close to the front door off Main Street. Their conversation was cut short by the sound of a large smack against the tiled floor.

Their stunned eyes followed the sound to discover a penny resting on the floor. Two odd things struck the trio. Unlike a normally dropped coin, there had been no bounce. Secondly, the coin was a good distance from both the cash register and the penny jar. They agreed the penny had appeared as if a ghostly hand slapped it violently on the floor.

"This kind of stuff follows me around," Dougherty remembers the customer stating at the time.

The staff's patience with their mischievous supernatural resident, named "Penny," was frequently tested since the ghost's antics often resulted in extra cleanup. Inside the kitchen, Dougherty once had several sandwiches stacked in various stages of preparation. Next to him, the chef, in the midst of finishing her creation, stepped away from the table. It then began to shake violently, causing everything to fall. Further culinary cutups included heavy French rolling pins and large spatulas rising from shelves and holders to fly across the kitchen area past bewildered employees ducking for cover.

Penny's preference for performing impish acts during the restaurant's slow times revealed itself again one hot summer day. Regular customers, affectionately called the "Monday Ladies," were perched at their favorite

front window table. Conversation between them and the staff centered on the recent odd happenings. As more clients came in, they, too, entered the discussion.

One Monday Lady left to use the restroom as the first patron of the day to do so. First, she needed to borrow the key dangling from a mini green colander. Still holding the bulky key set, she returned seconds later, her face ashen.

"You are never going to believe this," she said beckoning everyone to follow her to the unisex restroom. There, evenly spaced around the curved handicap railing, rested seventeen pennies. Amazement gave way to humor as someone joked at least Penny was giving tips. After Dougherty collected all the coins, everyone thought the incident was over.

They thought wrong.

Several minutes later, as if in déjà vu, the same woman returned to the restroom only to hustle back quickly in shock and surprise. The copper color of a new penny shone brightly against the middle of the tiled floor.

Although the current building is less than twenty years old, the land underneath has been the foundation for many businesses, like the gold rush–era Adelphi Saloon. It is plausible James Marshall, the discoverer of the gold that began California's fabled gold rush, was a frequent patron. Could Marshall, considered by many to be one of history's biggest losers due to his endless bad luck, be the mysterious Penny?

On two occasions, blurs of energy, roughly about five foot six in size—the height of Marshall—have been seen and felt charging from near the side door toward the front. In the floor-to-ceiling windows composing one side of the shop, other figures have made appearances.

The side door opened to a narrow passageway and small courtyard housing other specialty shops. As they closed earlier than Zia's, the courtyard's two gates were locked past 6:00 p.m. This also blocked access to the stairway to the upper floor.

One night, during cleanup, Dougherty heard his co-worker gasp. She had just seen a tall man with a beard hurriedly pass by the eastside wall of windows. Thinking the gates were mistakenly open, Dougherty went out into the courtyard only to discover them still locked. Then he climbed the staircase, certain the unwanted person waited upstairs. He found no one.

At present, the store at 312 Main Street stands empty. However, chances are good that plenty of spirits remain inside.

CHAPTER 16
THE LADY IN WHITE AT 537 MAIN STREET

In Placerville, history as far back as before the California gold rush easily merges with modern day. The spirit world also effortlessly transcends barriers of centuries and loves to interact with business owners of today. Some of the latter are fearful or not interested in starting a relationship. Others welcome the entities as parts of an old building like creaking floors. For the years Hangtown Tattoo was located at 537 Main Street, the business welcomed its ghost.

She was a young woman. Judging by her appearances, white was her favorite color, according to owner Dave Cameron. While some cynics scoff at the familiar "lady in white" scenario, often presented in tales of ghostly hauntings, historical fashion information proves the legitimacy of the claim.

In the latter 1840s, before choices of merchandise were readily available in the Sierra Nevada foothills mining camps, respectable young women would not have worn gaudy colors in public. Additionally, in a region where summer heat can easily top ninety degrees, unless one was forced to wear dark-colored mourning attire, most women and girls opted for light colors that reflected the sun's intensity.

Cameron recalled first discovering his entity through a sudden drop in temperature, often followed by an unexplained sense of depressed heaviness. Paranormal enthusiasts explain that both signs are signals of an unhappy spirit. Whatever happened in this young woman's life to depress her is lost to the ages due to fires Placerville fell victim to in 1852, 1856 and 1910.

537 Main Street with next-door fence.

The spirit typically manifested near the open doorway between the front and back rooms of the tattoo parlor. Situated in proximity to the tattoo tables where Dave and his staff created body art, they could not decide if their lady in white was merely curious or forlorn that she no longer possessed a body capable of being inked.

She appeared to be about twenty-one years of age with long brown hair. Her gown was white with lace embellishments along the upper part of the bodice and trailed the floor. At times, she was also dressed in blue jeans and a white shirt. Perhaps when alive she had been the daughter or a young wife of an early miner.

Despite speaking to her before she disappeared into a shadowy dust, Cameron was never able to gather information on her identity.

While her garb was demure, her restless soul was given to mischievous doings. Gazing out the front window one day, Cameron saw the arrival of a new client with his mother behind the wheel. The driver turned on the car's directional to indicate to others her intention of making a right turn off Main Street.

As the car pulled into the driveway, it suddenly swerved to the right, almost hitting the low metal fence of the neighboring Rood Building. It was here that John Studebaker's wheel shop was once located. Rushing outside to ascertain his client and mother's conditions, the tattoo artist found them physically fine, but the mother was livid. She demanded to know how someone could jump in front of her car during broad daylight.

Almost hesitatingly, Cameron informed the woman there had not been anyone on the sidewalk, much less in front of her vehicle. Again, her anger erupted. How could he have possibly missed the pretty young brunette whose hair swept past her shoulders and was dressed in a white frock?

When told the description matched that of the tattoo parlor's ghostly resident, the woman paled herself.

On another occasion, Cameron and his friends were jamming to some music in the upstairs' apartment over the store. A sudden gust of wind and the plummeting of the room's temperature announced the arrival of something unearthly.

In trying to explain the spirit sharing both the living and business spaces, Cameron realized one of his friends was more fixated on the ceiling than his story. Following the other man's gaze, he was stunned to see the ceiling fan making extremely slow rotations. Unlike the rotations found when the unit's power had been turned off, its rhythm was steady yet very unnatural.

"Dude, how do you get it to do that?" his astonished friend asked.

Taking charge of the spirited invasion, Cameron stated there was no need for fear or anger as the long-dead young lady was welcome to enjoy the camaraderie of the living. The simple invitation provided the calming effect needed. Within minutes, the room's temperature was normal, as were the blades of the ceiling fan slicing the air.

One person sent me an anonymous e-mail after hearing about Placerville's Lady in White on our ghost tour down Main Street. For over an hour on one March night around midnight, the writer sat in his car in front of the shop and waited. His reward came in the form of a silver-colored orb dancing around the side counter in the front room. After watching its graceful movements for three minutes, he decided he wanted a better look and to take a photograph.

Quietly, he exited his car and treaded toward the front windows. About five- feet from his destination, the orb stopped sharply before disappearing into nothingness. Had it been the young girl's spirit that, when realizing someone was watching her, had turned suddenly shy?

Some wonder how long it will take the Lady in White to appear to the new tenants at number 537. With Darrell, the ghostly resident of the Chamber of Commerce Building, living across the street and known for his own ramblings, people have asked if he and the Lady in White ever get together. No documentation of such a phantom pairing has been unearthed. It could be that the elderly Darrell is simply too old for her.

CHAPTER 17
PLACERVILLE NEWS COMPANY

Unlike many Western towns that have turned their colorful past into heightened exaggerations of the real deal just to please tourists, Placerville's history is easy to embrace for both visitors to the Sierra Nevada foothills and the people who live and work around there.

Nineteenth-century buildings that once entertained thirsty miners now offer chai, tai chi and historic artifacts. Restaurants now stand where once gold dust was accepted currency. At some Main Street businesses, it is very easy to appreciate the city's changes over the centuries. Such is the case at number 409, where reading material has been sold since the days of the Mother Lode. Starting in 1856, many an Argonaut walked into the Davis and Roy News Depot. They were looking not only for California-based news but also for updates from hometowns, often thousands of miles away.

The original one-story wooden building, constructed with slate, shale and native stones, was divided into two separate businesses under one roof. Each shared a common wall. While the newsstand occupied the eastern half, the western portion housed the first county hospital for El Dorado.

In the latter part of the nineteenth century, leading citizen Shelley Inch took over the edifice. Under his ownership, major alterations were made. A second floor was added, the common wall was removed and replaced with a steel I beam and cast iron cloaked the front of the building's now Italianate architectural design. Adding to the cast iron's grandeur—the only building in Placerville with the material used in such a way—were ornate columns

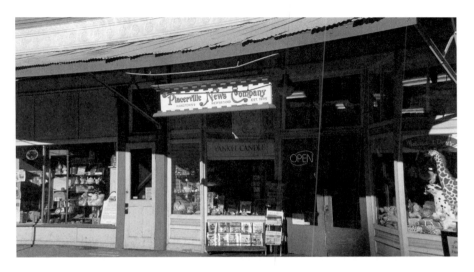

Placerville News Company.

and a parapet with Inch's name in large letters. It was evident Mr. Inch wanted everyone to remember his name.

Eventually, the store changed to the Placerville News Company. The name stuck, and so has a family that has been running it for over one hundred years.

Four generations, with a fifth in training, of the Duffey, Meader and Webster clan have provided newspapers, chewing gum and all other necessities in life since 1912. Three of those generations lived above the store on the second floor. Members of the family are also the keepers of tales of some supernatural happenings.

It was current matriarch Mary Meader's grandmother who bought the Inch Building in 1919 after seven years of being a News Company employee. Her career had begun after being widowed, seven years earlier, and left with a small infant boy. While no recorded accounts of supernatural events can be found from his great-grandmother's tenure in the family lore, Jeff Meader is sure some long-departed Placervillians still spirit about.

He said, "It could from when the doctors were here. You know some people died tragically."

In a recent experience, Robert Oliver must have met one those unhappy souls. As a scryer, he frequently experiences paranormal dealings even while doing his normal activities. In late 2013, when browsing in the back of the store where greeting cards are displayed, one of these experiences occurred. He almost fell completely backward. Because there was no object behind

him that could have caused the mishap, he immediately knew it was nothing from the physical world. Instead a spirit, strong and invisible, had given him a fast shove. Who, what and most importantly why still remain a mystery.

While none of the Meader family members have experienced a forceful encounter like Oliver's, some have felt the presence of unearthly beings. One encounter was almost bittersweet, according to Christine, who works alongside her mother and brother. A longtime customer passed away. One day not long after his death, he appeared briefly as an apparition to Christine. The store was quiet, and he stood where he always did, near the front door and to the left of the cash register.

While it was a bit disconcerting, she felt comfort. She said, "It was almost as if he had come by just to tell us he was okay."

Sometimes the staff and other decades-long clients still think George Duffey Jr. is checking up on the family business. Until his death in 1998, he was well respected and beloved in the community. He was the kind of guy who would open his store in the middle of the night to sell hunting licenses or tell a would-be robber to scram. He also had an eye for detail, which our ghost tour group on January 3, 2014, witnessed firsthand.

Standing outside by the large window at the west side of the then-closed store, one woman commented on one Christmas decoration that was spinning all by itself. Dangling on a thin thread from the ceiling, a red glitter ball spun around and around. I commented that it might be near a heating vent.

As I continued to tell the ghostly tales, I realized the entire group's attention was no longer on me. Instead, everyone was peering intently into the darkened store. By now, four more sparkly balls were also spinning. Having never encountered this strange phenomenon before, I had no explanation. All I could do was volunteer to go into the shop during the upcoming week and inquire as to the location of the heating vents.

A few days later, Jeff pointed them out. One was over the front door and the other in the back room. None were located near where the decorations had twirled.

When I met with the entire family to interview them for this book, I told them about the odd experience. With a grin and a chuckle everyone agreed it had to have been Dad or Grandpa. George Duffey was just making his rounds to assure everything was in tip-top shape.

CHAPTER 18
SPIRITED FUN DOWN AT THE LEVEE

L aissez les bons temps rouler" is the tagline at the Cajun-inspired Levee Restaurant in downtown Placerville's Creekside Place. Situated over the meandering Hangman's Creek, it has become clear to owners Robert and Sonya Huff that the good times roll for their living and dead patrons.

Frequently, upon returning to the restaurant they left in pristine condition, they find things in disarray. Glasses, especially those for drinking wine, and dishes clutter the empty bar and tables.

"More than once, I have walked in here and asked the ghosts if they had a party while we were out," said Sonya.

Being around apparitions and mysterious occurrences is nothing new to the Huffs or their daughter, Brandy. Sonya and Bob grew up in or familiar with haunted places in the Deep South and Toledo, Ohio, respectively. Brandy remembers since childhood having the ability to sense and see things that others could not.

One night, a diner told them that Hangman's Creek had been the source of several deaths, not surprising during the early gold rush days. The site of one of the few water sources running through Placerville, sporadic hot-tempered fights between miners were known to break out. If a violent death did not take a miner, a few sips of the heavily polluted creek water could.

Bob recalled in the following e-mail what occurred, usually late at night, shortly after they bought the former Café Luna in 2013.

Inside the Levee.

We began to hear sounds. One night there was an extremely loud knocking on the floor near the restaurant office. I couldn't exactly determine where the sound was originating. So I checked the office, checked the back room, checked the sink closet. The sounds were 2–4 knocks in a row...then a pause for about a min or two...then more knocking. It was so loud, I would compare it to a sledge hammer [sic] being pounded on the floor. However the sound was more like "wood on wood" so I might compare it to a large log being thrust on the floor. It echoed throughout the restaurant.

After about 10 min of this banging...I decided to put an end to it.

So I stomped on the floor near the area, but this had no effect. With no other reason for the sound, I quickly ran outside and went down the steep embankment to see who was under the restaurant. There was no one there. There was no sledge hammer [sic] or log, no sign of anyone being under there.

I came back inside the restaurant and the banging stopped.

It's happened several times since then, but not as loud, and doesn't last as long. I will usually yell "this is not funny, stop it."

Other times late at night, alone in the restaurant, I feel an eerie sensation of being watched...and not by 1 or 2, but being watched by many. I would guess 25 plus entities are in the restaurant. This creeps me out. It seems as if I do nothing...then the sensation just grows stronger and stronger by each passing minute. Therefore I occasionally

say the following statements out loud... "Go to the light" and/or "In the name of Jesus Christ, be gone."

One night I was again, working late, alone in the restaurant, stocking the wine racks. Our wine racks are floor to ceiling, over 7-feet tall.

I was hunched down on the floor, gently sliding wine bottles onto the bottom rack. I had this sensation, or "knowing," that I should look up.

"Look up" kept coming into my mind. So I decided to go ahead and oblige these thoughts, and when I looked up, there was a wine bottle on the top shelf, pushed half way [sic] out, teetering on the verge of falling onto my head. This really creeped me out. None of the other bottles had moved...so why did this one bottle, directly above my head, slide out of the rack?

Another day I was doing a lot of carpentry work in the restaurant. I use my hands every day at my job, working with tools, installing parts on machinery, etc...

But this particular day at the restaurant, it didn't matter what I picked up in my hands, to carry across the room, it fell out of my hands. It seemed like no matter what I picked up, it was knocked out of my hands. Screwdriver, pliers, pieces of wood all knocked out of my hands.

I took my lunch break, picked up my plate, and it fell to the floor. This went on all day.

I finally reached my limit when a box of nails, "boom" got knocked out of my hands, fell to [the] floor, with nails going every direction.

A lingering negative energy was felt by Sonya soon after taking over the restaurant. Unwilling to let it remain, especially after several bottles of red wine flew unaided by human hands to crash near patrons at the bar, she lit a sage stick and let its healing smoke waft from room to room. Now the remaining entities only display their fun and curious nature. They act up around staff. Similar to other spirits, they are mesmerized by modern electric items. The time clock refuses to allow employees to punch out at the end of their shifts. Boxes of miniature Christmas lights fall without provocation onto unsuspecting heads. Despite being turned off, plugged-in calculators and the cash register display numbers without the benefit of electricity.

On the day I interviewed Sonya, I also took interior photographs. I captured the lively décor in color, but something else appeared by the patio side doors when I switched to monochrome. Two orbs appeared in one shot and disappeared in the subsequent one taken seconds later.

A week went by before I went back into the restaurant. Nothing unusual happened until I left. As I pulled the door shut and walked onto the patio over the creek, I not only felt but also saw a dark shadowy figure by my left shoulder. In the semi-darkness, the only distinguishable features I could make out was that the person appeared to be hunched over and about five foot eight.

"Excuse me," I muttered as I turned to walk out of Creekside Place. There was no reply, but I did not think it was weird until three steps later, when I pivoted around to get a better look. No person stood on the deck or had entered the Levee. Being more surprised than frightened I continued walking toward Main Street—just at a faster pace than before.

CHAPTER 19

LIONS PARK'S OLD PROSPECTORS

Whatever the season, Lions Park, located two-miles southeast from downtown Placerville, is always full of activity. Fans fill the bleachers to cheer softball players rounding the bases, while strollers on the walking paths enjoy a variety of bird songs as delighted squeals of children echo from the playground. Only during the last three decades have the park's recreational areas been developed. Until then, much of the land was covered by native trees and brush. It resembled a landscape that many nineteenth-century miners had known.

Old maps found at the El Dorado County Historical Society's research library pinpoint the numerous mines that once ran along and under its neighboring Cedar Ravine Road. Some, like Alderson and Hoskins, might have honored those toiling for hidden riches, while others, such as the Union and Old Union, reflected patriotic fervor before, during and after the Civil War.

Crisscrossing under the park remain the collapsed mining shafts of the Linden Mine. Whether it was named for a former owner or the large trees still dotting the park's twenty-four acres, few alive still care. Instead, they wonder about the identity of the miner still seen occasionally near the abandoned mine.

Their curiosity stems from the fact that the mine's heyday was from 1882 to 1894. During those years, over $130,000 in gold was extracted. Unfortunately, just three years later, the mine was attacked in court by its employees after their wages had not been paid.

Lions Park's tennis courts.

Former Placerville policeman Tom Carroll recalled his own encounter back in the 1980s. It happened during a routine inspection of Lions Park during the nighttime hours. As the headlights of his squad car pierced the inky darkness, he was startled by a sight in front of him.

Slowly shuffling under the trees, where the tennis courts now stand, was a miner leading his mule. The apparition did not linger long. Luckily for the law enforcement officer, trained to remember even the briefest of encounters, the memory remains clear.

Wearing clothes typical of the era—red flannel shirt, blue jeans and a beat-up hat—the ghostly Argonaut and his pack animal, loaded with gear, quickly disappeared into bushes and low-hanging tree branches.

In recent years, others have reported seeing a similar figure near the same area during different hours of the day and night.

"I was waiting for my tennis partner just before 8:00 a.m.," said a resident of El Dorado Hills who wished to remain anonymous. "The huge rainstorm the night before left puddles on the court. Everything was still damp."

Deciding to practice his serve, he lobbed two cans worth of tennis balls over the net. He walked over to the other side of the court and had picked them up when something against the tree line caught his attention.

He said, "It was the damndest thing, but I swear I saw an old miner come out between the trees. At first I thought, 'Is it Halloween?' Then I remembered it was April."

The tennis enthusiast stood entranced, watching the apparition as it walked away from him along the elevated hillside. His stunned brain remembered some of the entity's details. A checked red shirt with a bandana tied jauntily around the neck was part of his ensemble. The hat atop his head was black felt and, as witnessed by Tom Carroll years before, a bit tattered. Unlike in Carroll's sighting, the miner's mule and tools were missing. With his back toward the tennis court, it was impossible to see the spirit's face to ascertain his age or any distinguishing features. After less than a minute, the ghostly miner faded into the trees as easily as he had appeared.

In early 2014, I repeated the stories to a friend as we sat in a local coffee shop.

"Is Lions Park the one off Cedar Ravine and near the airport?" asked a woman at the next table.

When I said yes, she first apologized for eavesdropping but wanted to share her story. Several months earlier, in the late afternoon she had taken her eight-year-old nephew to the park to practice catching baseballs. Nothing was out of the ordinary until they decided to walk the long way back to the car. On the slight rise of the hill overlooking the athletic fields and tennis courts, she caught a glimpse of an old man holding a shovel. He was on her left, out of her nephew's view and pointing to the ground. Turning quickly to speak to the little boy, when she looked back, the old man was gone. He couldn't have moved that fast, she remembered thinking. Where did he go?

Perhaps the old miner, unaware that he is long dead, still seeks his fortune or is trying to point out to the living an undiscovered rich vein of gold.

PLACERVILLE SODA WORKS

An imposing stone building anchors the upper section of Placerville's Main Street. Known as the Placerville Soda Works on the National Register of Historic Places since its inclusion in 1985, it is one of the city's oldest restored structures and also among the most haunted.

Just do not ask the staff of the present day Cozmic Café for great ghost stories. Upon my inquiry to the owner in September 2013, I was denied for the reason that "things have been peaceful for several years, and we do not want things to be stirred up again."

I respected the request. Luckily, I had stories from others and my own encounters with the building's supernatural residents, both human and not.

A little history and some myth debunking first. When Scottish native John McFarland Pearson constructed his one-story building in 1859, it was done with an existing abandoned mine extending into a hillside on the southern side of the property. The old mine's approximate 150-foot depth and twenty-two-inch-thick stone walls provided the perfect constant temperature for storing ice.

The building's cool past has led some to declare the building had once been a nineteenth-century morgue. While this could add to the already creepy aura felt when walking on creaking wooden boards toward the darkened tunnel, it is not true, according to records at the El Dorado County Historical Society Research Room.

After decades of supplying the locals with ice, fresh fruit juice–flavored soda water, domestic and imported wines and liquor, the Pearson heirs added a

Gold rush–era mine inside Placerville Soda Works.

second brick and stone story to the building in the late 1890s. Over the next century, it became a Coca Cola bottling plant, ice cream parlor and restaurant.

Paranormal investigation teams have been drawn here at least since the Cozmic Café's 2003 opening. Not all of what they have found has been human. The mewing cries of a kitten have been heard in various parts of the old Soda Works. Surely, cats were standard residents to keep nineteenth-century vermin under control.

Upstairs, along the ballroom's wooden floor, the sound of a young girl dancing was reported for some time. The rhythm is disjointed and far from synchronized. Imagine a youngster's carefree frolicking instead of a choreographed routine.

November 9, 2013, was a quiet Saturday night along Main Street. With the absence of customers, businesses, including the Cozmic Café, closed early. It was close to 9:00 p.m. when our last Ghost Tours of Placerville group ambled into the parking lot. Our lantern and the streetlights barely illuminated the otherwise dark area. As I recounted the Soda Works' spooky tales, suddenly from a partially opened upstairs window, everyone heard *thump da thump bud a bop thump* and then nothing. The spirited boogie's sudden stop was followed by a lack of footsteps—human or animal—which would have resonated along the wooden floor.

Aside from the sounds of spirits dancing, the ballroom has also been the site of other unexplained happenings. A local massage therapist recalled an

incident several years ago when a drum circle fundraiser was held for the floor's restoration. The energy level at such events is usually heightened, but this one grew to almost epic proportions. It was described as swirling around the room, and it appeared that more than just the humans were participating. Finally, when word from downstairs arrived that the chandeliers were swinging wildly, the drumming ceased and left many awed at what they had experienced.

With the money raised, a pair of men were contracted to restore the floor's luster in 2005. Wanting to begin earlier than the staff's arrival, they opted to spend the night in the building.

During the early morning hours, one was ripped from a peaceful slumber by the horrified screams of his co-worker. What he awoke to see was almost incomprehensible. His buddy, still encased in his sleeping bag, was being dragged around the room. The obviously strong tormentor remained unseen but left a lasting impression. Following the floor restorer's release from the horrifying ordeal, handprints appeared on his upper thighs.

A similar story was related by a ghost tour participant on March 1, 2014, who was unfamiliar with the previous incident. A few years ago, in her job as a mortgage refinancier, she met the then owner of Cozmic Café, who shared an odd happening.

She had allowed a small group of hikers to also sleep upstairs. Once again, one of them in a sleeping bag became the victim of an invisible phantom. Snatched from his sleep, he was twirled round and round the dance floor until ending up thrown into a corner. The group also reported unexplained shuffling sounds of feet coming across the floor behind the bar and mysterious plunges in temperature in the same area.

Could it be a powerful man from the past who has been witnessed by the bar area? An article in the October 25, 2007 issue of the *Mountain Democrat* mentions the appearance, however brief, of a brawny male clad in the usual miner's garb of flannel and denim seen during a paranormal research outing. His appearance is a bit unkempt, with a straggly beard and matted hair. He has been given the name of "George." Unfortunately, no one of such a name is found in historical records as either a disgruntled owner or a patron with a burning desire for revenge.

The same article described additional cold spots indicating the presence of other entities. One group, near the mouth of the cool tunnel, are miners playing cards. It would have been an ideal spot for cards in the nineteenth century, like now, when summer outdoor temperatures soar to near one hundred degrees.

During the same paranormal expedition, two members were about to set off deep into the mine. Wearing hard hats with attached headlamps, they were told by the medium that they were not alone. An old gold miner had joined them in spirit. No doubt, he was familiar with their trek and fascinated with the battery-powered lights that now lit their way, unlike the candles of his day.

As a gathering place for a diversity of events ranging from yoga to Tibetan monks' seminars and board game tournaments, the café's clientele can be as varied as Placerville's population during the gold rush days. Some people, like Scrabble players who use the café for regular games and tournaments, have felt the presence of dead miners. They claim they are the unnamed Chinese who died during a collapse of wood, stone and dirt. Placerville has many collapsed tunnels crisscrossing under Highway 50 and downtown. Several, like those at the back of the Soda Works, are reputed to have been built so leading citizens could easily visit gambling parlors and brothels without being noticed by curious eyes.

An ill-fated young girl is rumored to have taken a deadly tumble down the dumbwaiter shaft in the nineteenth century. Until a paranormal team's arrival, no one gave thought to the horror of the girl's last few moments of life. Two team members wearing knapsacks felt them strongly tugged when they passed the place of death. The tugging was not strong enough to slow anyone down, but it was not a gesture of mere curiosity. Psychics believe the hard yanks stemmed from the dead girl's everlasting desperate attempts to grasp something that will save her life.

Directly across Main Street from the café lies one of the city's parking lots, the Ivy. Its western edge borders Hangman's Creek and provides a meeting spot for many of Placerville's teenagers. When the night air is cold and the downtown's activity slows, a few of the young people have claimed to have seen the shimmering image of a young woman staring out from the closed café.

The appearance of another girl has upset a few employees when sighted. After the café has closed downstairs and events upstairs have ended, it is usually after 11:00 p.m., but staff can be still found in the building cleaning. One employee was upstairs behind the bar when he looked up to see a little girl standing on the other side. She was strangely dressed in Victorian clothing. The episode became more bizarre when the employee asked, "Where are your parents?" Rather than reveal their whereabouts, the child simply vanished.

Fascination with water is a typical trait of many gold rush ghosts of Placerville. Those at 594 Main Street have shown they are equally beguiled. Water in sinks turns on and off without the help of human contact.

Perhaps, in part, to pay for any increase in the building's water bill, phantom pennies will periodically drop from the ceiling. Oddly, the copper coins are all recent releases from the United States Mint. As the identified spirits come from the nineteenth century, some recipients have questioned where the ghosts have obtained the money. Could they also be pickpockets?

Whatever one might order at the café, it is important to know it can comes with a side of high-spirited activities.

CHAPTER 21

THE SMITH FLAT HOUSE

Technically, the now restaurant and healing center sits three miles from downtown Placerville, but as its mailing address has the former Hangtown's zip code, its spirited tales are being included here.

The stories of ghostly events stem from the gold rush when rich veins were discovered underground at the place with the changeable name of Smith's Flat, Smith Flat or Smithflat. This necessitated the need for tunneling, and thus the Blue Lead Mine began. Its location on an ancient tributary of the American River meant its yields were impressive. Also, being situated along the toll road that forty-niners trekked over the Sierra Nevada to California's gold fields and then to the Comstock Lode's silver cash provided the perfect place for a hotel and toll station.

Originally, when constructed in the early 1850s, the building was called the Three Mile House. Aside from its sleeping rooms, it also housed a grocery store, post office and basement saloon. This must have made it a popular spot as Blue Lead miners emerged from the mine's depths via its mouth under the building.

From the mid-nineteenth to early twenty-first century, the building's owners and purposes changed. One thing that has never altered over the years is how the past loves to interact with the present.

A local nurse told about having dinner at the now acclaimed restaurant downstairs in the old, stone-lined cellar in October 2012. When she entered the upstairs' restroom, her nostrils filled with an agreeable musty smell like

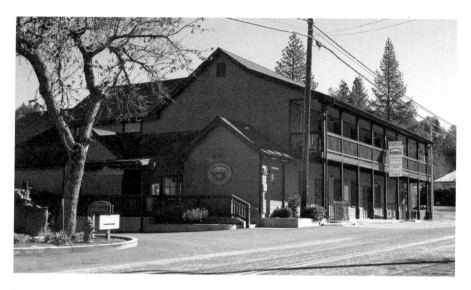

Smith House flat.

that of old books and leather combined. Unsure of its origin, she did not dwell on it until she faced her own image in the mirror. She was not alone.

Next to her stood a slightly transparent man, about forty years old, with a matted red beard. Although his clothing was dirty, it was made of high-quality materials. A waistcoat of yellow silk was worn under a dark frock coat. His blue cravat was wound loosely around his neck, and atop his head, he wore a slightly tattered stovepipe hat. Obviously the man in the mirror was a gentleman. Death had not robbed him of his manners. Before disappearing into a mist, he tipped his hat.

"I thought I had had too much wine with dinner," she confessed. "But now I am sure I saw someone."

This scenario was familiar to me. Almost a year after the nurse's ghostly meeting, I was enjoying dinner at the restaurant with Jody Franklin, director of El Dorado County's Visitor's Authority. Before leaving the outside patio, Tim, our waiter, invited us to follow him to the downstairs' room and bar. After showing us the gaping hole, once an entry to the Blue Lead Mine, Tim led us to a piano across the room. There he began playing classical music. As the impromptu concert continued with low lights illuminating the stone walls, I had the feeling there were more than just the three of us there.

"Can't you imagine all the miners sitting around with glasses of beer, laughing and singing to the music?" asked Jody.

"I don't see them laughing," I replied. My mind's eye suddenly was aware of miners being in a more reflective mood, with some wiping away sentimental tears. Many Argonauts lived cultured lives before coming to the Mother Lode. Common to all had been the enjoyment of good books and music, along with the best of foods and wines. Being surrounded daily by the rowdy existence of the early gold rush days made many of them long for their former lives. A concert of classical music supplied emotional relief. Apparently, it still does.

However, not all the spirits are refined. Some are eternal pranksters. While enjoying a glass of wine on a slow Wednesday night in January 2014, a female bartender told me about an abnormal and unexplainable incident. One night, two employees stood outside chatting in the parking lot, near the courtyard entrance. Their talk was interrupted when one of their cars started up. Momentary surprise became pure shock as the automobile could only be activated by keyless remote, which was inside the restaurant. As if to further amaze the two, the invisible mischief-maker also flipped on the headlights. Jumping into the car, its owner drove it twice around the parking lot before he was able to get it to stop.

Two weeks later, the phantom driver wanted another chance behind the wheel. Another member of the staff had parked his car in the exact same spot. Again, without the aid of a key, the car's ignition started but the lights were never tested.

At the Smith Flat House, the past still drives the present.

CHAPTER 22
GOTHIC ROSE ANTIQUES

People entering 484 Main Street usually stop dead just beyond the doorway as an amazed "wow" escapes from their mouths. Gothic Rose Antiques is aptly described by owner Crystal as "the coolest shop this side of Transylvania."

A Victorian-era satin funeral fan, once held by a grief-stricken woman, stands next to a collection of postmortem photographs of the same era. Near a cemetery sign is a jar of small skulls. Lurking in window displays and throughout the shop are vintage mannequins and ventriloquist dummies, each wearing dark clothing from the past. Wherever your eye lands, there is something unusual and occasionally slightly sinister to see.

Having been a fixture on Main Street for seven years now, it is no wonder a few ghosts, like those at other downtown businesses, have settled in. One came with Crystal, while another has been part of the property for centuries. A perusal though historical records found the earliest deed of the property belonging to a C.A. Clark in 1849, just a year after gold was discovered in nearby Coloma. Had this Clark been a lucky miner able to strike it rich quickly and become a landowner?

Other owners since the building was constructed prior to 1872 included Judge Marcus Bennett, the same Bennett who has been seen as an apparition in his former mansion on Bee Street.

One of the known spirits is named Tom. Perhaps Peeping Tom is a more accurate name, as he tends to reside in Gothic Rose's fitting room. First identified by a tarot card reader during her weekly sessions, he appeared as

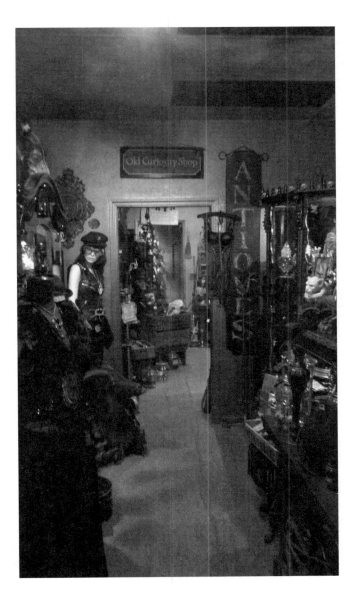

Interior of Gothic
Rose Antiques.

an almost translucent man with a beard. "Madame Know-it-All," the tarot card reader, felt his presence in the same area where young boys had earlier captured an image of an odd green mist with their digital cameras.

Whoever haunts the fitting room, it is good to remember that he was probably lonely for female companionship in the earliest days of the gold rush. Personal hygiene was a challenge in a place where water was scarce

during the summer and fall months. Basically, if Tom had been able to afford a date, his stench might have kept the ladies away. Now in his afterlife and freed of his telltale odor, he is able to appreciate women all he wants.

A disagreeable smell might have helped local graphic designer Robert Oliver. It would have warned him of a ghost's proximity. In late 2013, intrigued by Gothic Rose's unique items, he and his wife, Millie, were perusing the shop.

While standing close to the fitting room, he felt a hand touch his shoulder and then run down his arm. The pressure grew harder.

"Are you ready to go?" he asked, turning around to face his wife—but Millie was not there. In fact, nothing living was near him.

Shortly after the first incident, and across the store, he was again touched by an unseen hand. This time, the hand lingered in almost a seductive way. Oliver, well versed in supernatural things, was chilled. His body started to tingle. He struggled to keep his eyes open. When he was physically able, he asked out loud, "Are you the same person who touched me earlier?"

No spirited answer was forthcoming.

Could Tom have exited the dressing room ready to offer affection to both genders? Maybe it was the shop's other ghost just being friendly.

Crystal admits that, after a considerable time searching for a location, she felt spiritually drawn to Placerville. Perhaps the spirit leading her had been her late Aunt Blanche. Like many in Crystal's family, Blanche also had a true passion for collecting unique antiques. Several of her treasured possessions are in the shop. One in particular has scared customers.

One day, a young couple was looking around the back room where smaller merchandise is found in antique glass cabinets and apothecary cases. Crystal, seated up front by the cash register, was startled when the woman suddenly screamed.

Rushing to them, she found both people slightly shaken. The woman pointed to a small book lying on the floor near her feet. Still somewhat hysterical, she exclaimed that the book had levitated from its perch on a shelf and flown toward them. The travel book, entitled *Guas Artistias de Espana Valencia (Water Artists of Valencia, Spain)*, normally rested in a small bowl on a low shelf. This made it virtually impossible for it to simply fall off its perch. Coincidently, a psychic, who lived a few blocks away, happened to be in the shop at the time as well.

Her gift with working with the dead immediately caused her to say the color blue was prominent in the shop at the moment. It had nothing to do with a still depressed spirit calling from beyond the grave. Instead, she

saw an older woman with tightly curled gray hair. Blue, having been her favorite color, also figured prominently in the woman's wardrobe. She was seen wearing something blue, shabby and soft to the touch.

Immediately, Crystal confirmed the entity's identity as her aunt, who loved searching through vintage shops and flea markets. One of her most beloved finds had been a blue velveteen coat. So faithfully was it worn that when Aunt Blanche had died, it was in tatters. In an interesting side note, the levitating little book had a blue cover.

Aunt Blanche also made herself known to me with dramatic flair on a Saturday night in November. A woman identifying herself as a psychic had joined our 6:30 p.m. ghost tour. The stop at Gothic Rose Antiques comes midway on the route. Typically, I stand on the north side of the building, next to a small gated courtyard. On this evening, a sudden coughing fit hit me. Nothing I did stopped it.

"It's Aunt Blanche," yelled the psychic. "She suffered from asthma."

I choked out that I was not asthmatic, and her next statement was that she was the very same person who had identified Crystal's departed relative. When I finally regained my voice, she also told me I needed to change my position, saying, "Aunt Blanche always needs to see you."

At the 8:00 p.m. tour, I changed the routine and planted myself directly in by the shop's front windows. To add a bit more insurance to guarantee no further interruptions, I also silently said, "It's only me, Aunt Blanche." She must like the recognition. Never again have I had another spirited attack.

CHAPTER 23

THE CHILDREN OF PLACERVILLE CEMETERIES

At least half a dozen cemeteries of El Dorado County's two hundred are located in Placerville. Some are dedicated to those who practiced a particular faith, like Catholicism or Judaism. Stories of hauntings passed down over the years stem from two cemeteries: Placerville Union and Old City.

The former, created in August 1871, has served as the final resting place for members of the city's fraternal orders. Masons, Odd Fellows, Ancient Order of the Druids and the Knights of Pythias members are among those whose lives and deaths are honored with simple stone headstones or elaborate carved monuments.

Many of the Union cemetery's dead are the city's movers and shakers of the late nineteenth and twentieth centuries. Some, who came as the region's first Argonauts in the 1840s and '50s, made their money and stayed. Others arrived later or were among the second and third generations of Californians.

For the doctors, lawyers and merchant kings sleeping at the Union, none of their grave sites are connected to a ghost story. That is reserved for a plot decorated with a small stone engraved "Marcus." The accompanying dates show he lived to be only three years at the dawn of the twentieth century. To his left are the remains of his baby sister. His parents, Marcus Sr. and Mary "Molly" Bennett, rest to his right.

During a period when cemeteries provided a recreational place to visit, many an Edwardian visitor was taken aback to see the small boy playing

Old City Cemetery entrance.

over his grave. The apparition never played long before disappearing into his grave. His parents' deep grief, palpable to their contemporaries through wistful looks and solemn moments, extends to the present day. Judge Bennett is seen at their former home, the Bee-Bennett mansion, while Molly appears there and over her son's grave. Although she died at the age of ninety-nine in 1952, her ghostly apparition is that of her younger self with upswept hair and elegant fashions of the turn-of-the-twentieth-century's popular Gibson Girl.

Another toddler's grave across town attracts sorrow from the beyond. During the winter months, when the trees are bare, many people are surprised to see old tombstones atop a hill that overlooks the western portion of Placerville. It is Old City Cemetery. Here are found the dead from the time when the city was called Dry Diggins and Hangtown. There is a definite sad atmosphere among the tilted gravestones. It grows when closest to the grave of Willie Bee, son of Colonel Frederick Bee, one of early California's most prolific citizens.

Also claimed by death at a young age, the four-year-old is alone in his final resting spot. Unlike little Marcus Bennett, who is surrounded by family, Willie's closest relatives are buried nearer to San Francisco, over one hundred miles away. His lonely sadness is still evident from the sounds of weeping that have been heard coming from below young Bee's grave.

Described as inconsolable, the noise has also attracted those seeking to bring relief. Those comfort bearers are also dead. Irregular gray and white-

colored wisps of different shapes and sizes have been witnessed moving slowly over the plot containing the little one's earthly remains. One witness, acknowledging he had snuck into the cemetery illegally after dark, said the motion of the wisps were reminiscent of a mother rocking a child to sleep.

The dead are still able to have deep feelings, as evidenced by these sad cemetery ghosts.

CHAPTER 24

SMALL SPECTER ENCOUNTERS ALONG MAIN STREET

While some ghosts have made and continue to make their presence known to past and present merchants along Placerville's Main Street, others have only offered fleeting encounters.

The mission of the Painted Owl, at number 376, is to recycle, repurpose, re-create and re-love items from the past. The latter was what owner Heidi Mayerhofer and her staff offered to their temporary specter. This was not always easy, for "Charlie," as they nicknamed him, was a bit of a stinker.

Pranks were not his forte. A lingering odor was.

"It was the smell of someone who had not bathed in a long time," recalled Mayerhofer in late 2013. Luckily, the overripe aroma only manifested along one section of the shop's back wall, usually not accessible to the public. Still retaining its original bricks, city records indicate the building was constructed prior to June 1886. Before that, the Round Tent Store Saloon and a stable were on the site. In 1855, the Daily Amador Stage Coach picked up passengers from there.

No one was able to pinpoint the smelly specter's real-life story. After six months of acknowledging the foul-smelling male presence, one day he simply disappeared.

"I think he just grew comfortable with us and the store," said Mayerhofer.

Finding comfort with new designs and people in old buildings is important to many of Placerville's ghosts. Two doors up from where the hangman's tree once stood at Elstner's Hay Yard, a former miner named John had a message for the new storeowners at 321 Main. Being dead and without a physical voice meant his communication skills were limited. Spirited attempts were

Placerville's Bell Tower.

made to connect with the Winterhill Olive Oil's owners and staff. He played with the cash register and rearranged the merchandise. Finally, according to Annette Schoonover, he resorted to contacting a psychic, who entered the store one day, announcing she was only there to deliver a short missive: "John wanted you to know that he likes what you have done to the place."

She could offer no further information to John's identity or connection to the shop's address, but my research showed that the next-door store in the same building was owned by a John C. O'Donnell. There he established a tobacco shop. His father, also named John, was the original builder of the gold rush–era's Empire House, which became a theater and now antique shop. Just who John was still remains a mystery, but after accepting his thumbs up from the past, peace again was restored.

Words flew at 352 Main Street over the late twentieth and early twenty-first centuries when at least two bookshops occupied the space. Books were known to levitate and sail off shelves without any human assistance. Cold spots and the tinkling sound of glasses were felt and heard repeatedly. During a paranormal investigation in 2007, one team member identified a spirit by the name of William. In 2010, a psychic also felt a strong male presence.

Some thought a saloon had once occupied the site. Historical records show that the building was one of Placerville's first to be rebuilt after the disastrous fire of 1856 consumed much of the city. To safeguard it from further infernos, sheets of iron were adhered to the front of the building. Before they were taken down, two harness makers were documented to have occupied the building over the years. Current shopkeepers do not report any unusual activities. Perhaps William and his friends are just on vacation.

Next door at 372, a number of spirits have been identified over the years by several paranormal investigations. The building's uses since its nineteenth-century construction have been varied. Cafés, bakeries and two different ice cream parlors are just a few. The sweet tooth of the specters was demonstrated when one owner would arrive in the morning to discover various tubs of ice cream in the freezer without their lids. The ice cream was untouched, but the lids had been licked clean.

An obvious culprit was the shop's nine-year-old boy ghost, called Charles. His affinity for food displayed itself the last time number 372 was used as a café, when Charles played with the panini machines.

Cooking and baking had been important to a woman said to reside in the backroom. She was described as a Victorian-era schoolmarm type, complete with a high-collared dress, a tight bun and a stern look across her face. It is said she did not suffer fools well in life. That did not change with her death. It was said that if she heard any insulting remarks or ignorant comments, she fell into a fury evident by flying plates and

cutlery. Witnesses claimed to have occasionally seen a red-haired little girl next to her. A daughter, perhaps?

Starting in the 1850s, the Empire Theater was the place to be seen and entertained in El Dorado County. Its luxurious stylings, namely parquet floors and opera boxes, were on par with the finest theaters in bigger cities like San Francisco. Seating 1,500 people, it was packed for almost every performance. However, one of the greatest attractions did not appear on the stage but along the Empire's broad aisles.

The owner's adorable little girl, under the age of six, would walk up and down with a pan. Miners, many of them fathers and brothers far from home and family, willingly placed nuggets of gold in the pan in appreciation.

By the 1930s, live shows were replaced by film. Many a Placervillian remembers going to the movies at number 432 until April 14, 1997, when the theater closed. Some former patrons recall exiting and being accompanied up the aisles by mysterious mists that were gone by the time they reached the lobby. According to former city police officer Tom Carroll, not all the entertainment was found on the stage or silver screen. In the 1980s, he was taken into the alley and saw small cribs once used by prostitutes from the early days of the gold rush until the twentieth century.

Now a vast array of antiques fills the cavernous building. Ghost impressions, a common term for when spirits attach themselves to their former possessions, have been felt here by several paranormal experts. Some say a particular painting continues to be the favorite of a young boy.

Many of Placerville's spirits searched for gold during its Dry Diggin's period when drinkable water was scarce. Is this what makes them continually fascinated by running water in the twenty-first century? They love to show their happiness, anger and frustration by playing with it.

Hannah Darr's watery experiences with "George" at her Redneck Bling shop at number 492 were brief but eventful. The back of her store, used for storage, was extremely cold even on days when temperatures were brutally hot. Sometimes, incomprehensible voices were heard. The spirit's favorite hangout was the bathroom. As a living person used the facilities behind a locked door, George would often enter unseen and turn on the sink's faucet.

One day, his antics redeemed him. On a day when the store was closed, Darr and her husband entered it. Suddenly, the sound of running water on full force attracted their attention. In the bathroom, it appeared George was just having fun—until they realized the sink was not draining.

Several hours later, a plumber repaired the problem. He informed them that the problem had been caused by a clogged pipe in the back alley. Had it gone on unnoticed, it could have easily flooded the store.

The plumber said, "It was a good thing you were here and had turned on the water."

John Studebaker is a name many recognize for his early twentieth-century automobiles. It was with the thousands of dollars he earned as a wheelbarrow maker in gold rush–era Placerville that he supplied the earliest capital. Historic documents and plaques pinpoint current number 541 as the old Studebaker workshop, while old photos show a building large enough to include modern-day 545 as well.

Now Filo's Bakery and Café, owners Todd and Gabby start baking their breads at 3:00 a.m. Even at such an early hour, they were aware someone was standing across the street peering into the café's floor-to-ceiling windows. Due at first to the figure's extreme stillness and black vintage clothing, they thought it was an abandoned scarecrow set up against a locked dumpster. Then it moved and proceeded farther up Main Street. With the haunted chamber of commerce building diagonally across the street, they are now certain they saw the chamber's resident specter known to stroll after midnight.

Odd occurrences continued. In the back kitchen, pots and skillets rattled and cups would fly off shelves when all the workers were in the front.

"It was almost like someone was walking by very fast," recalled Gabby.

The unexplained disruptions continued and reached a culmination when an overhead light crashed down. Rather than continue to welcome a destructive spirit, a spiritual cleansing with sage was held in 2013. Energy once negative was replaced with positive vibes. Weird things still happen, but they are all good.

People wait patiently for a table at Sweetie Pies, even when the line snakes out of the restaurant, down the front steps, through the patio and out onto Main Street. For twenty years, Patty Clark and some members of her staff have experienced sudden sightings of people obviously long dead. Dishware and cutlery of the twenty-first century appear to fascinate these visitors, but no one can ascertain why.

While it could be the aromas of delicious foods or the energy of the living that attracts them, the possibility is great that the deceased spirits simply never left home. The late nineteenth-century cottage in the Queen's Anne design at 577 Main Street was one of the few homes built along the upper length of the street.

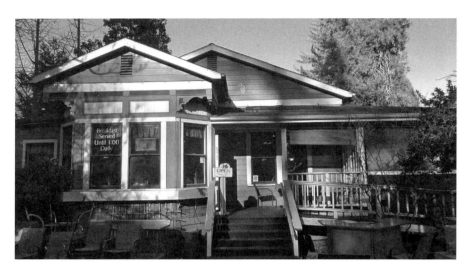

Sweetie Pies.

Sharing a wall with the periodically eerie old Placerville Soda Works has allowed the tenants of number 582 to also experience some unusual things. For over a decade, the Empress has welcomed shoppers into its vibrantly colored interior. Airy fabrics, many in the form of sparkly belly dancing costumes and scarves, hang from the ceiling. Vintage and unique jewelry join stacks of incense and CDs to create a fun atmosphere.

Owner Carole Smith remembers when a unique item went missing for two weeks. Thinking it might have been shoplifted, she was glad and a bit mystified when it reappeared overnight two weeks later.

Saucy Hill, an employee, reported some odd experiences that occurred during past shifts. A row of rings kept being moved from its usual position near the cash register to across the aisle. Was the responsible ghost also once a clerk in an earlier store once on the premises? Perhaps he still wanted to demonstrate his merchandising skills.

Two young men in their early 20s once told Hill about seeing lights flashing across the darkness of the closed store. One also remembered being pressed up against one of the shop's window by a strong invisible force.

Hill accepts the times when the atmosphere is thick with supernatural vibes. She says, "I feel that nothing is out to hurt me, so I have no fear."

COLOMA

CHAPTER 25

UNEXPLAINED HAPPENINGS ALONG THE AMERICAN RIVER

On the eastern shore of the American River, off Mount Murphy Road in Coloma, less than a mile from where James Marshall dipped his fingers and pulled out flecks of gold, Nisenan Native Americans lived on the land for the thousands of years. From the river, they gathered trout and other fish as the woods provided bear, deer and turkeys. Autumn was harvest time for the plentiful acorns from surrounding trees. Grinding stones, like the one at the nearby Marshall Gold Discovery State Historic Park, were used for turning the nut into flour. For generations, the traditions of their lives continued mostly unhindered—until the gold seekers arrived.

Many Nisenan and other tribal members of the Miwok people knew where gold existed. As thousands of newcomers flooded their lands in search of the gold, the Native Americans realized its immense wealth. Many began mining the mineral themselves until they were driven away or enslaved by more powerful Argonauts.

Abuse and murder was frequently inflicted on the peaceful Native Americans by miners desperate for their gold-producing land. From 1848 to the early 1850s and beyond, few, including the appointed lawmen of the time, gave considerable thought to their rights.

Now on the former Nisenan site, once called Kullomah, an outdoor school offers year-round lessons on nature, science and history. Amy Harris is a fourth and fifth grade teacher at an El Dorado County elementary school. On her class's annual two-night stay in January 2014, she and other teachers experienced odd occurrences. Being so close to the river can offer the best

6921 Mount Murphy Road.

opportunities for specter sightings, according to many paranormal experts. The energy generated by running water, even at wintertime's low level, is considered enough to allow a spirit to manifest itself. That could explain how Harris saw an apparition of an older, heavyset woman near the riverbank.

Harris explained, "She appeared to be close to my height, about five foot four. I could not see much more of her as she was very white and transparent. She disappeared quickly."

The other female teacher's encounter was more personal. Between the school's registration cabin, which also houses a mercantile store, and the closed front gate, she felt a hand run down her back. Turning around, she expected to find a student, but she was startled to find no one standing close enough to have administered the touch.

Later that night, on the deck of the cabin she and Harris shared, she saw a distant figure between five foot eight and six feet. Her first thought was that it was her colleague, Gary Burns. However, the figure wordlessly disappeared into the night's darkness close to the river.

Burns, an amateur ghost hunter, had his own brush with the supernatural beginning on the first evening while standing on the registration cabin's porch around 8:00 p.m. The bead and leather pouch he had worn as an identification badge for several years suddenly fell into a crumpled heap at his feet. Some people would believe the leather straps had simply come undone. However, as a former member of the United States Coast Guard,

Burns takes pride in tightly securing items with a variety of knots. He felt that non-human hands, curious at its Native American design, had loosened the square knot to take a closer look.

Early the next morning, the mischievous entities along the American River continued pulling pranks while many slept. Inside Burns's trailer, as he began his day, all the lights suddenly dimmed. Knowing the unit was fully hooked up to a reliable power source and not running on batteries or a generator, Burns looked at the electrical box, trying to spot any flaws. There were none.

The lights remained low for over an hour. Soon Burns found it difficult to see inside and had to open the trailer door. Then, as rapidly as the incident had begun, and without a plausible explanation, the lights resumed their full illumination.

When the trio of teachers compared their separate experiences, questions arose. Was there something unresolved from the past that had brought spirits to the present?

One of the earliest books written on California's Mother Lode country suggested an answer. Written by E. Gould Buffum, a soldier turned journalist, *Six Months in the Gold Mines* was based on his detailed journals. In it, he tells the tale of a struggle between the Native Americans and whites along the north fork of the American River. It resulted in deaths in Coloma. To retaliate for the murders of the miners, caught while working the claims, a group of Anglos went off in pursuit. Some twenty Native Americans were killed near Weaver Creek. Thirty more were brought back to Coloma, where a trial for six commenced. Sentenced to death, they were led to an unspecified field, and five were shot dead. The location remains a mystery.

After their first night was spent having separate disturbing dreams, Harris and her roommate decided to offer prayers of peace to the spirits.

"We told them we valued their presence, and the culture[s] that had been theirs. We also stressed we were here with the kids and wanted them to learn important lessons from the past," said Harris.

Combining prayer with the thoughts that generations of Nisenan families had lived tranquilly on the same land where they now slept gave them an uninterrupted slumber for the final night.

At no time did anything occur to or near any of the schoolchildren. It was apparent that the entities living off Mount Murphy Road cherished young people. Respect for Coloma's first settlers was the school's greatest lesson.

CHAPTER 26

DRIVING ON PROSPECTORS ROAD

In the rural parts of El Dorado County, it is still easy to envision similar landscapes where Argonauts of the Mother Lode lived, worked and died over 160 years ago. Throughout the foothill chaparral country on the western slope of the Sierra Nevada, pickaxes, shovels and even Bowie knives and bare hands clawed the earth in search of golden riches. Many chose to stand or squat for hours in the often-freezing water of streams, creeks or the American River.

Backbreaking work under all conditions frequently yielded little rewards or none at all. Miners often worked their claims alone. Disappointment combined with extreme loneliness proved a lethal combination for many. Suicide proved the final answer.

For those who persevered, there were always other threats. One that usually proved fatal was being robbed for their cache of gold. Bandits roamed, individually or in groups, looking to make money without the labor.

Along Highway 49, just north of Coloma, is a blinking red light indicating a four-way stop. Turn left onto Marshall Road and within one half mile is tiny Prospectors Road. Often bypassed for the larger and more popular Marshall Road, it leads across hilly terrain to the small town of Garden Valley and Highway 193. At the intersection with Marshall, it appears like just another scenic country lane. However, this road has proven deadly due to the appearance of a miner—one who has been dead for years.

Reports of a tall man wearing a fierce look on his weathered face suddenly appearing out of the dense brush along the side of the road have occurred

Prospectors Road sign.

since the nineteenth century. His clothes are usually in tatters, not unusual for a miner with big dreams but little cash.

Typically, he gestures frantically, as if to frighten people. Legend says he has been occasionally observed mouthing the words "stay away." The commonly accepted scenario is that he is trying to protect his gold. Who is he trying to protect it from—claim jumpers or robbers who might have murdered him for his riches?

Tens of thousands of miners, a lack of official police forces and poor record keeping during the earliest gold rush days created an ideal scenario for criminals. The remoteness of the goldfields offered another bonus to those planning nefarious acts. Few, if any, would find the aftermath of a heinous crime, and if the evidence were ever discovered, the murderers would be long gone. As recently as the early 1990s, the area became a known dumping ground for bullet-ridden and decapitated corpses of murder victims. A lieutenant with the El Dorado County Sherriff's Department, James Roloff, was quoted saying that calculate the vast number of bodies laying undiscovered on and around Prospectors Road would scare the modern-day populace.

Some gold rush miners died alone under tragic circumstances, entombed and smothered when their poorly constructed tunnels collapsed atop them or due to a gun accident suffered while in pursuit of food.

No one knows the name or fate of the ghostly prospector along Prospectors Road. What is known is that his apparition has been blamed for many accidents, some fatal. As the seven-mile road winds its way along hilly ridges, wagons, carriages and then automobiles have driven off the roadway's edge only to plunge down steep embankments lined with trees and boulders. Drivers of cars, motorcycles and even mountain bikes have reported the unexplained loss of control of their vehicles or sudden swerves to avoid strange figures.

Besides being a troublesome roadside hazard, the specter also strolls and has the ability to pick locks. He has been blamed for the twentieth-century entering of a cabin along the road, despite its front door being dead-bolted. His presence was made clear to the young couple renting the house when they awoke to discover the open door and a concentrated coldness in different parts of their home, despite it being heated by a wood-burning stove. Their dog, found trembling in a corner, also confirmed the paranormal visit.

Cautionary advice is given to all who still travel on Prospectors Road. If suddenly a patch of weeds along the shoulder of the road starts to move without a breeze, the driver should immediately focus his or her eyes straight ahead. This action will help avoid seeing the old prospector's luring gesture to pain or even death.

CHAPTER 27
JAMES MARSHALL MONUMENT

On Cold Spring Road, just past the Highway 49 junction, a slightly weathered sign in the identifiable brown and cream colors of California's State Park System points the way to the James Marshall Monument. Along the winding road with a gradual ascent, there is a sign declaring Highway 153 to be the shortest one in the entire Golden State. Only one half mile in length, some question the validity of the claim.

One claim no one can doubt is the importance of James Wilson Marshall to the California gold rush. His discovery of gold flakes along the edge of the American River, barely a mile away, began it all.

Unfortunately, if there was a reality show called *History's Greatest Loser*, Marshall could easily be a top contender for the prize. After hearing the story of his life, no one is surprised to encounter his sad supernatural self. He is often found forlorn at his grave under a towering monument at the end of Highway 153.

Some of his woes were self-imposed due to his love of alcoholic drink. His 1878 attempts to get the California State legislature to increase the renewable pension he had received for the past six years were unsuccessful. In fact, his pension was stopped entirely. This occurred after a bottle fell out of his pocket, leaving an oozing mess of shards of glass and brandy on the marble floor of the assembly's gallery during the hearing.

Other calamities in his life simply happened because he was a victim of circumstances. A native of New Jersey and a trained carpenter, his migration westward included stops in the Midwest from Indiana to Kansas and Missouri

Illustration of James Marshall.

to farm. However, several years of crop failure forced him farther across the country. His mid-1840s arrival in California brought him better fortune. Captain John Sutter hired him as a handyman at his Sutter's Fort, now present-day Sacramento. This regular influx of cash allowed him to invest in land and cattle.

Marshall's arrival also coincided with California's territorial upheaval of American settlers against Mexico. Soon he marched with John C. Fremont in the Bear Flag Revolt, a precursor to the Mexican-American War during the same decade.

Within a year, he was back near Sutter's Fort, exhausted and unpaid, and sad to find his cattle herd stolen. Forced to pay his debts by the sale of his land, an offer by his former employer, Sutter, promised to be a boon.

They became partners of a sawmill to be constructed along the south fork of the American River, located in the Coloma valley among the lushly tree-laden foothills of the Sierra Nevada. Marshall agreed to oversee the construction. At its completion, he would stay on as the manager, for which he would receive a portion of the cut lumber.

All that changed on January 24, 1848. Realizing the mill's tailrace portion was too shallow to operate the saw properly, Marshall's crew of Mormons and Nisenan Native Americans worked through the night of January 23 to free it. In the morning, as Marshall examined the situation, he saw flecks of gold glistening under the icy water's surface.

"Boys, I think I found gold," he commented—not "Eureka!"

As the world rushed in, Marshall's world collapsed. Abandoned by his gold-hungry workers, the Coloma sawmill soon failed. He tried to join in the frenzy by mining himself. Unfortunately, thinking he had mystic powers, superstitious treasure seekers followed his every move.

Leaving the Coloma area, he returned in the mid-1850s to build a cabin and plant a hillside vineyard. Life again looked promising until competition

Sutter's sawmill.

and taxes ran Marshall's winery dry of funds. New ventures through the next two decades included two lecture tours, as well as ownership in a gold mine and a hotel in Kelsey, approximately six miles northwest of Coloma. All failed.

In recognition of his important role in California's young history, he began receiving a monthly $200 state pension in 1872. Renewable every two years, Marshall continued receiving money until the fateful day of the broken brandy bottle.

He lived on until 1885 in a small Kelsey cabin, surviving on wages from occasional blacksmithing jobs and produce from his small garden. Although his clothing was tattered, his hair was matted and he reeked of creosote, an antiseptic distilled from wood tar, Marshall was a respected neighbor.

After his August 10 death, debate arose as to where to bury the old pioneer. Wagons of ice were driven up the twisting mountain road from Placerville to preserve his corpse from the summer heat. When the decision in favor of Coloma was reached, Marshall's body made the last journey across Mount Murphy to be laid to rest in his former vineyard.

Members of the Native Sons of the Golden West and others soon began a plan for a more fitting grave site for the discoverer of California's gold. In 1890, thousands scattered across a hilltop for the dedication of the Marshall Monument. From its granite base, a ten-foot, six-inch-tall statue of Marshall, made in an alloy of tin, lead and zinc, crowned the top. Painted bronze, the

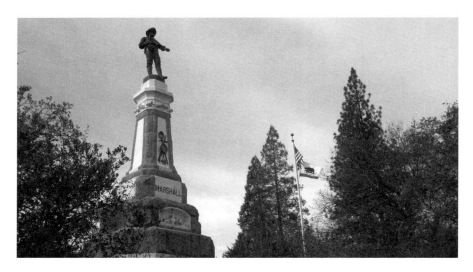

James Marshall monument.

statue held in one hand a gold nugget, while the other pointed forever to the place by the river where he made his historic find.

Over 120 years later, Marshall's statue still points down the tree-covered hillside as thousands of vistors come annually. Many are California schoolchildren from around the state. A trip to the Marshall Gold Discovery State Historic Park is often a requisite in fourth grade. Excited chatter and laughter often fills the air as groups circle the monument while teachers loudly call out historical facts.

Then comes the time when the crowds are gone and only the sounds of nature are heard. There is a rustle of the wind through the leaves of trees or creaking of bare wintertime branches. Overhead, the cry of a hawk breaks the solitude. It is during these quiet times that the ghost of James Marshall appears.

Tom Micheals is a self-confessed Gold Country history addict. Although born and raised in the Kansas farmland, his earliest memory of his fascination's birth was watching the 1960s epic film *How the West Was Won*. Seeing stars like Debbie Reynolds and Gregory Peck cross the country en route to the California gold mines gave him a goal. He made future plans to get there.

Thirty years later, he moved to San Francisco. On one of he and his wife's frequent weekend jaunts to El Dorado County, they made plans to revisit Coloma and the state park.

Shortly after the park opened on a November morning, they decided to eat their breakfast under the pine trees of the monument's picnic area. Something caught his eye in the distance, but he passed it off as a low-flying bird. When the couple walked up to the monument, Micheals trained his camera on Marshall's statue. Looking through the viewfinder, he saw something unreal.

Perched high and facing him, with an arm wrapped around the towering statue, was an almost translucent male figure. Only visible to its mid-thigh, the entity's resemblance to James Marshall was unmistakable.

Dropping the camera from his face, Micheals yelled to his wife to look up. Nothing remained on the statue—until Micheals looked through the camera again. The strange sight remained but only momentarily.

Others, like visiting New Yorker Jeane Cooper, claim to have seen his tattered figure standing at the base of the monument looking up. Her encounter occurred briefly in late January 2014 around 3:30 p.m. She first thought it was just another visitor like herself, as she gazed up from the circular walking path surrounding the statue. Upon reaching the upper level, she was able to see the old man, "almost looking like a sickly homeless person" still there. As she walked closer to the two flagpoles approximately twenty feet from the statue's west side, the odd-looking man disappeared from her sight.

Cooper assumed she would get a closer look when she reached the statue. However, amazement struck her when she discovered she stood completely alone on Marshall Summit. After buying a book at the park's mercantile store, her amazement turned to shock. The shabby man she had seen thirty minutes earlier now stared out from the book's pages. It was James Marshall.

She told me her story a few days later at the state park's annual commemoration of the gold discovery. It confirmed what I myself had experienced by the statue in the past.

Although I have never actually seen James Marshall's ghost physically, I have sensed his spirit in the same area. Like Cooper, I have been alone on the hilltop, usually in the morning. Standing in front of the statue with views of Mount Murphy behind me, there has been an undeniable heaviness. This has occurred on a gloomy day and one where the sky was bright blue and sunny.

Less than fifty yards away are several wood and glass–enclosed signs that tell the story of Marshall and the gold rush. As I read them, right to left, in November 2013, I heard a man sigh over my left shoulder. Knowing only my car had been in the parking lot and seeing only my reflection in the glass, I spun around to find no one. I continued reading. Then I noticed

despite there being no breeze, a collection of cobwebs in the last sign's lower left corner began to move strangely. Their flimsiness floated almost like being stirred by an unseen hand. Again an audible sigh was heard. As I was standing at the sign containing a photograph of Marshall, I could not resist asking aloud, "Is it you?"

There were no more sighs nor a concentration of unexplained heaviness on Marshall Summit that morning—just the feeling old James was happy to be spoken to.

JAMES MARSHALL'S CABIN

It sits nestled into a crook of a narrow and winding road in the Marshall Gold Discovery State Historic Park. Despite the occasional repair with new lumber, to some visitors, the historic cabin once belonging to James Marshall still has a weathered and forlorn feeling about it. Unexplainable things happen by it and inside it.

Never open to the public, one only has to stare through the cabin's rippled glass windows and view its stark interior to understand the harsh reality Marshall lived for decades before his 1885 death. Many of his gold rush contemporaries slept their nights away in elegant hand-crafted beds comfortable from steel springs under thick cotton mattresses, thanks to their Mother Lode fortunes. Yet the man whose initial discovery of several flecks of gold began the massive global migration to California slumbered atop a handmade bed of twisted tree limbs covered with a thin mattress crafted from the poorest of materials.

Instead of immediately seeking wealth from mineral riches he pulled from the waters of the American River, Marshall attempted to honor his commitment to his partner John Sutter and complete their sawmill. With this rested their hopes of striking it rich. Unfortunately, while his sense of obligation was strong, temptation overcame his workers' sense of duty, and they left to mine on their own.

Eager Argonauts began to arrive within weeks of Marshall's January 1848 find. They first came from the Southern California Mexican land grants and the Oregon territory. The next swell of gold seekers arrived from where

James Marshall's cabin.

ships from San Francisco had first docked following the announcement of the gold's discovery. They included the Sandwich Islands, China, Chile and other Pacific ports. Within eighteen months, tens of thousands entered the harsh wilderness of Northern California's Sierra foothills, all in hot pursuit of the elusive precious metal.

When his sawmill proved unsuccessful and his land became overrun by claim jumpers, Marshall also took his turn at gold mining, but he had a unique problem. Many sought divine intervention in their search, and when it came to attaching oneself to a patron saint, poor Marshall fit the bill to those disillusioned souls. They followed him everywhere, certain of his ability to find another gold cache. This proved so unsettling to Marshall that he eventually left Coloma.

Upon his return several years later, he found short-lived success in agriculture and winemaking. It is recorded that he grew fifteen different varieties of grapes before increasing competition and high taxes forced him to leave Coloma forever until his burial in August 1885.

He also likes to go home again. Local lore states he has been spotted slowly hiking up and down the hillside, looking right and left, at various times of the day. Is he inspecting the condition of his long-gone vineyards?

At his old cabin, accessible only during daylight hours, Marshall appears in different forms. A paranormal expert from Placerville took photos that

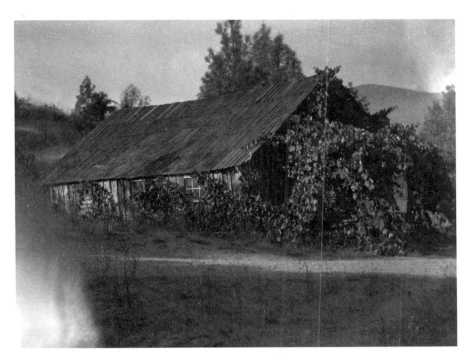

James Marshall's cabin. *Courtesy of California State Parks, 2014.*

captured a misty figure. When enlarged, a man's face was easy to spot. His shocked and open-mouthed expression probably mirrored that of the photographer. Could this be as a dumbfounded Marshall appeared when he looked out the window to discover the hordes of superstitious gold seekers waiting on his doorstep?

I did not find any ghostly figures on any of my photos of the cabin. However, what was evident were rather large orbs in front of its right side. They floated several feet away from the structure. Could one of them have been the spirit of James Marshall, or did he solely remain up by his grave? If none were Marshall, were they the specters of his gold-crazy groupies?

A San Francisco traveler who had seen a translucent Marshall hanging around his bronzed likeness on the grave half-expected to see him also at his former home. An apparition of the grubby prospector did not appear again in a physical form. Instead, at several places, short raspy coughs were heard where no live person was standing.

The cabin is across from St. John's Catholic Church. Established in 1850, it sits encircled by swaying tall pine trees. The church is unused, except for

weddings and special occasions, and there is a small burying ground directly behind it. The cemetery was the final resting place for several of Coloma's original families. Tombstones span from the mid-nineteenth century until the early twentieth. Despite its age, no local residents or investigating paranormal teams have reported spirited activity there. That is found less than a mile away at the older Pioneer Cemetery on Cold Spring Road.

CHAPTER 29
THE VINEYARD HOUSE

M ention Coloma's Vineyard House to many old time El Dorado county residents and be prepared for one of two replies: "It had great food!" or "It was one of the creepiest places."

Still visible from Cold Spring Road, less than a mile from the Highway 49 intersection, it sits behind a locked gate. Now a private house, it is not known if the current owners intend to revive it to its former glory as a favorite area restaurant.

They are left in peace to do what they desire. However, a big question hangs in the air. If all the reported hauntings that have plagued the building for almost a century are true—can peace actually be had?

Built in 1879 at the cost of $15,000, its foundation was formed with large boulders quarried from nearby Gold Hill and the old Coloma jail, unused since the early 1860s. At the latter, at least one prisoner committed suicide in his cell. In 1852, a botched hanging due to faulty ropes and knots by Sheriff David E. Buel resulted in prolonged pain for the two prisoners.

Did such agony attach itself physically to the stonework used to build the Vineyard House's foundation? Surely, sadness and tragedy manifested across generations have left lasting impressions with the living. Hysterical screams, flying glassware and ghostly appearances are just a few of these manifestations.

Prior to the house being built, the land's first owner, Martin Allhoff, was a gold rush success story. The German immigrant arrived with thousands of other Argonauts in Coloma during 1849. Upon acquiring enough gold dust, he transformed it into real estate with the initial purchase of thirty-five acres.

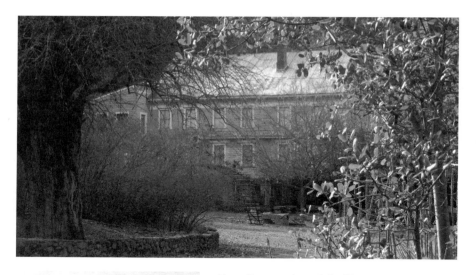

Above: Current view of the Vineyard House.

Left: Illustration of Martin Allhoff.

His prosperity grew following his 1852 marriage to French-born Louisa Weaver. Unlike others still laboring for metallic wealth, Allhoff found riches in wine. On over 160 hillside acres, he cultivated a variety of grapes. His winemaking skills created one of California's largest wineries outside the Napa Valley, according to his son. The sales of his fermented liquid spread far beyond the Coloma Valley. By the mid-1860s, his clientele included Nevadans drawn to mining the extreme cache of silver found in the state's famed Comstock Lode.

A trip to the Silver State proved to be Allhoff's undoing. While in Virginia City, he was charged with improper tax payments. Ashamed at what later proved not to be his fault, the winemaker slit his throat with a butcher knife in the privy of the city's St. Louis brewery on October 9, 1867.

Wine label used by Robert Chalmers. *Courtesy of California State Parks, 2014.*

As a widow with young sons to raise, Louisa soon found another suitor and within two years became the wife of Robert Chalmers. A good-looking man with thick and wavy dark hair, the Scottish native earned his community's respect with his expertise in both business and local politics. Already the owner of the renowned Sierra Nevada Hotel on Coloma's Main Street, upon his marriage, he increased the products and sales from his new wife's inherited winery. In addition, they built the Vineyard House in the late 1870s. Soon it was hailed as one of the finest inns of the region.

Like many business and civic leaders of the day, politics intrigued him, and Chalmers became a state legislator. Sadly, shortly afterward, Chalmers's empire of superb agriculture and accommodations faced a sudden threat when he fell ill. Some say it was syphilis that quickly drove him blind and insane. Unfortunately, an early twentieth-century windswept fire through the county's courthouse turned the confirming death report into ash.

When, in 1880, her husband was declared unable to manage his personal and business affairs, and far from a state or private institution to assist with his ever-increasing crazed symptoms, Louisa's options for his care were limited. To preserve his safety and that of the Vineyard House's paying guests, she chose to keep him at home in the basement.

Down in the home's dank and dimly lit cellar, behind iron bars and often in chains, Robert Chalmers spent the remainder of his tortured life. As madness ate away his last grasps of reality, he refused any food in the belief that Louisa was poisoning the meals. Before dying on June 2, 1881, from starvation, his wild and anguished cries and the metallic rattling of chains filled the air both inside and outside the family home and inn.

Some say these cries can still be heard along Cold Springs Road, especially across the road where Chalmers's red granite grave marker looks over his former home and prison.

Having two husbands dead from unnatural causes, Louisa's marital reliability was viewed suspiciously by many. Some thought another Scotsman, Thomas Hardie, an extremely brave man when he married Louisa in 1885. Census records show him still alive and with her twenty-five years later in San Jose, California.

With its eighteen graciously decorated guest bedrooms, fabulous wines and delicious fare, the Vineyard House's reputation for excellence never faltered under Louisa's watchful eye until she sold out.

During the twentieth century, as its fame as an inn and restaurant continued to grow, stories of hauntings and supernatural encounters began to surface. Some proclaimed that Louisa was still exacting her high standards from beyond the grave. She lies opposite the road in the Pioneer Cemetery under a simple headstone shared with her first husband, Martin. Others were certain that past tragic events, like Robert Chalmers's descent into lunacy, were the source of the creepiness.

A 1988 *Sacramento Bee* article recounted the odd occurrences of Diane Van Buskirk. She was the sister of one of the owners at the time. During her early 1970s tenure at Vineyard House, numerous times she found hand imprints on the linens of freshly made guest beds. They were not made from the housekeeping staff.

Jerry Kessler, an employee with the neighboring Marshall

Mrs. Louisa Allhoff Chalmers. *Courtesy of California State Parks, 2014.*

Gold Discovery Park, recalled the story of one-time owners and the middle-of-the-night concerts that interrupted their sleep.

A late nineteenth-century piano, perhaps once the property of the oft-widowed Louisa Allhoff Chalmers Hardie, stood in the parlor. Without guests sleeping in the house, it began playing a tune—badly. This occurred several times over the years. Finally fed up at the disturbances and the unknown identity of the phantom player, the owner stood at the top of the stairs and yelled down, "If you're going to play, why not play good music?"

Evidently, his command struck a chord with the ghost. Never again was a note heard coming from the piano unless it was played by human hands.

Music seemed to attract at least two ghosts in another encounter. Kessler's late brother Jim and their uncle Larry Davison were deejays at a wedding sometime in the 1970s. Following the gig, they retired to the downstairs bar. Located in the cellar, it was buzzing with activity.

With beers in hand, the two, particularly Jim, began conversing with two other men seated at the end of the bar. "Uncle Larry," as Davison prefers to be called, could not recall the exact content of the conversation, but four decades later, his memory is clear on the two strangers' appearances.

"They were wearing cowboy attire, including big hats. Both were very dusty," he said, "like they had been out riding."

After a while, Davison and Kessler excused themselves to use the restroom. Upon their return, their new friends had seemingly left too as their seats were empty.

"Do you know those two guys?" Kessler asked the bartender.

Looking confused, the busy man asked, "What two guys?"

Bewildered, the uncle-and-nephew duo further explained that they simply wanted more information on the men they had been speaking to. Were they locals?

"Dunno who you are talking about," countered the barman. "I didn't see anyone sitting on those stools." Noting their stunned looks, he tried to pacify them by saying that sort of thing happened all the time at the Vineyard House.

Had the men been long-dead winery workers, covered in dust gathered while harvesting grapes under the hot sun of the late summer or early fall in the Sierra foothills? Perhaps they were former cowboys riding in herds of cattle along the sage-lined trails.

During times when the Vineyard House's spirits were agitated, patrons would find their cutlery being moved while eating, and wine glasses thrown by unseen hands frequently sailed across the bar area. If that was not a

shattering enough experience, the dining room's chandelier also crashed into a thousand shards one night. These incidents, along with a young girl's horrified account of feeling an unseen entity sitting next to her at dinner, caused former owner David Van Buskirk to start sleeping off the property.

Stories of the odd occurrences spread across the region. Instead of frightening away the clientele, the stories often attracted them. As one former patron told me, "Their chicken pot pie was terrific, but it was always kind of fun wondering who or what might be also joining us for dinner."

By the mid-1990s, the Vineyard House was closed and shuttered.

According to a former El Dorado County deputy sheriff, he and three other sheriffs took the opportunity to hone their skills at sweeping the vacant building. To law officials, sweeping is defined as thoroughly searching a premise. Working the graveyard shift, the lawmen entered under the cover of darkness. As beams from their flashlights crisscrossed the room, they realized they were in the bar, where the old remains of Robert Chalmers's former jail remained in the corner.

All seemed serene until a drop of water splashed one deputy's arm. Immediately, a quartet of beams shone directly on the ceiling above. Nothing damp was found.

Upstairs, in one of the bedrooms of the former B&B, the deputies moved in to open a closet. As the other three watched, one struggled with the wooden door.

"It appeared like it was nailed shut at the top," one recalled years later. "The bottom section was moving past the door jamb fine, but the upper section would not budge."

Then a second law official gave it a hard pull. This time the top section moved freely, but the bottom section remained solid and tight in the doorjamb. As the inquisitive group kidded one another about their apparent lack of strength, a third deputy tried his luck. Without any of its former resistance, the door swung open easily.

Before the four left the Vineyard House, the phantom trickster decided to play one more prank. Again, the same officer received another watery drip from the otherwise dry ceiling.

Ruth Frey McLaughlin was a lifelong El Dorado County resident before her death at age seventy-two in 1999. In a history book on the local region, she told of her physical meeting with the spirit of Louisa in the 1960s.

While enjoying dinner at the Vineyard House with her husband and friends, Ruth left the table to go to the ladies room. En route, she peered into a room with a large fireplace and a woman exquisitely attired. The elegance

of her lace-collared black silk dress was enhanced by a small hat festooned with roses that the woman held in her hand.

Struck by the loveliness of the clothing from a bygone era, McLaughlin praised the stranger. Her friendly statement failed to receive any acknowledgment. Instead, the woman walked toward the fireplace. As she passed, McLaughlin noticed more details, such as the darkness of the woman's hair, her trim figure and the odd gray coloring of her skin around her hairline and jaw. Now stepping into the room, she again attempted to strike up a conversation with the woman in vintage clothing. Once again her remarks went unnoticed as the other woman gazed up woefully at the portrait of a nineteenth-century man.

Feeling snubbed, McLaughlin went on to the ladies room. Upon her return, she again encountered the nonresponsive stranger near a full-length mirror. She was attempting to set her little hat atop her piled-up hair. Knowing her friend back at the dining table would appreciate seeing such a refined outfit from the past, McLaughlin hurried to bring her back.

Unfortunately, when the two women got back, the other one was gone. Their attempts to locate her were unsuccessful, as were their inquiries to other patrons and staff. The well-dressed woman in Victorian garb had simply vanished.

On another visit several weeks later, McLaughlin mentioned the peculiar incident to the owners. A knowing look passed between them before they declared it was the ghost of Louisa Weaver Allhoff Chalmers Hardie. They, too, had seen her similarly attired and directed the astounded McLaughlin downstairs to the bar where a photograph of Louisa was on the wall. Although Louisa was differently dressed in the photo, McLaughlin was clearly able to identify the mute and mysterious stranger she had encountered earlier. She also learned that the portrait she had caught Louisa's apparition staring at sadly had been that of Robert Chalmers.

Could, in death, his widow be remorseful at imprisoning him in chains down in the basement?

The answer was never uncovered. Unless the Vineyard House is once again opened to the public, we might never know.

MARSHALL GOLD DISCOVERY STATE HISTORIC PARK

C oloma's Marshall Gold Discovery State Historic Park is the Mother Lode of California's state park system. Along its shoreline of the American River, one event set in motion circumstances that continue to resonate around the world.

Strolling the unpaved and crooked path along the river gives one the best opportunity to imagine the past. On a cold January morning in 1848, James Marshall's puffs of breath formed small mists as he inspected the icy tailrace waters feeding the sawmill's large wheel. Then his eye caught that fateful golden glint.

While the discovery destroyed Marshall's dreams of affluence, the fortunes of others were realized. For years, Coloma was at the receiving end of the riches, but then it ended when the gold became harder to find. Many of the area's nineteenth-century occupants moved on. Others stayed and continued searching in their afterlife. In every way, Coloma is a ghost town.

Modern-day visitors might have difficulty imagining the now-quiet town teeming with thousands of people. Coloma's restaurants, gambling and prostitution houses, saloons and hotels rivaled those found in San Francisco. Gold dust, gathered from days, weeks and even months of backbreaking labor, also disappeared in just hours from other pursuits found in the town. Miners indulged in freshly made candy, a good cigar or sepia-toned daguerreotypes.

Over 70 percent of the old town now sits within the designated National Historic Landmark District of the state park. With buildings

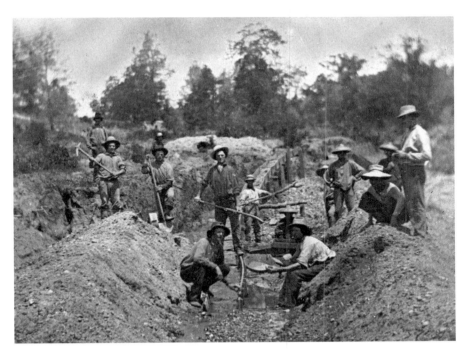

Gold miners circa 1850–51. *Courtesy of California State Parks, 2014.*

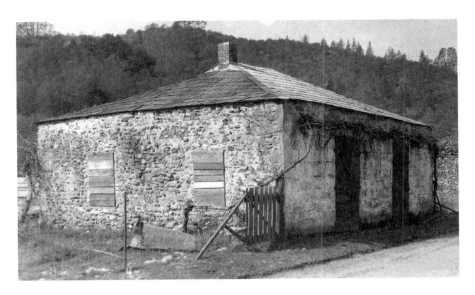

Man Lee Store. *Courtesy of California State Parks, 2014.*

reconstructed, restored and in monitored states of decay, meeting their ghosts is not difficult.

The Man Lee and Wah Hop stores are an easy stroll from the park's museum and visitors' center. After the glory golden years were gone, many Chinese miners settled in Coloma, despite California's anti-foreign movement. Regardless of the potential for brutal treatment and even death from other disgruntled ethnic groups, the Chinese knew, as do current American River Argonauts, that plenty of gold remained to be extracted. In addition, El Dorado County's new form of wealth—agriculture— was taking root in the form of fruit trees and grape vineyards. Chinese immigrants worked on many farms. By the 1860s, an estimated 1,500 Chinese were living within Coloma's town limits.

The sawmill left unfinished by James Marshall was turned into a dilapidated multistoried rooming house. Main Street businesses stocked merchandise essential to the increasing Asian population.

Built in the late 1850s, the Wah Hop kept the community fed with its imported and locally grown spices, herbs and other foodstuff. From the Man Lee, banking transactions were made and mining gear purchased.

In 1883, a fire swept through a cluster of Chinatown's tightly packed buildings. The only two to survive were the stone-built Wah Hop and Man Lee. It is the former structure that speaks from the past.

Voices, without bodies, have been heard inside the building. The rhythmic tone, too soft to understand, is thought to be Chinese, in the Cantonese dialect. Undoubtedly, fresh meat was available at the Man Hop due to the random sound of a cleaver hitting a wooden block.

Spirits of the past also congregate at the park's blacksmith shop. Just over one hundred years old, the current shop was built on the site of an old livery stable. Today, restored to its gold rush–era glory, its dedicated volunteers offer visitors an informative gaze into how malleable metals were formed into essential items.

On January 24, 2014, it was early afternoon when I walked into the shop. With one digital camera, I wanted to capture a bearded blacksmith's explanation of the astronomical steel prices of the 1840s. I was not looking for anything supernatural, but from the continuous shaking on the recording, something unexplainable was happening. I snapped a still shot with a second digital camera. That photo showed at least twelve orbs of varying sizes, shapes and transparency floating past suspended wooden wheels and over the forge's bellows and anvil. Obviously, Coloma's past is still active in the present day.

During the nineteenth century, the manufacture of guns was equally as important as shoeing horses and forging metals into tools. Jules Francois "Frank" Bekeart, a successful gold rush Argonaut, had an early life that read like a bleak Charles Dickens novel. Born in England in 1822, he and his four siblings suffered when their mother died young and their French-born father was incarcerated in debtors' prison. By the age of ten, Bekeart immigrated to New York City.

In his teens, he served as a gunsmith's apprentice. Wanderlust during his early twenties led him to trek across America. He fought in the Mexican-American War under future president of the Confederacy of the United States Jefferson Davis. As the war ended in February 1848, and while he was still in California, news of gold's discovery reached Bekeart.

Unlike others, he did not run to the goldfields. He returned to New York only to quickly book passage on a San Francisco-bound steamer. In his luggage were four hundred consigned revolvers. Upon arrival in Coloma, a log cabin was quickly rented, and his store was opened. Business was brisk. When it was not, he mined gold with luck. James Marshall became his friend. In 1850, the new gunsmith shop on Main Street was constructed of locally made bricks and lumber from Marshall's sawmill. As the supply of placer gold evaporated in the 1860s, Bekeart moved out.

The brick portion of his store still remains. Now the oldest original building in the state park, it serves as an attraction to twenty-first-century visitors and those from beyond the grave.

Jeane Cooper traveled from New York in early 2014 to see California's Gold Country. The unusually mild and rain-free winter weather gave her easy access to many of its historic attractions. In Coloma, she experienced not one but two spirit sightings.

The first was up at the James Marshall Monument, where she encountered the shabby, old pioneer himself. He stood by his grave in the long shadows of the late afternoon sun. Disturbed by the chance meeting, Cooper left the park to find food and drink nearby. Needing to return to Placerville, she drove south along Highway 49 in the early evening dusk. The road, still Coloma's Main Street, is bordered on both sides by the state park's buildings. Knowing the park was closed, Cooper thought it odd to see two small lights hovering near Bekeart's Shop.

Slowing her car to almost a crawl, she peered into the inky gloom. She hoped to see two park rangers holding flashlights. Instead, the green-edged lights, each approximately three inches in diameter, danced four feet above the ground without the aid of anything human. As another car appeared in

the rearview mirror, Cooper pulled off to the shoulder. With the lights still hovering, she ventured out of the car. Keeping her eyes trained on them, she reached the road's dual yellow lines when another car appeared in the distance. Momentarily distracted, she looked again for the lights, but they had disappeared.

Thoroughly spooked, Cooper admitted she ran back to her car, no longer willing to seek out the supernatural.

Curiosity was what brought teacher Gary Burns on a nocturnal walk along Main Street. Coupling his long interest in unexplained phenomena with a two-night class trip to Coloma gave him the perfect opportunity for some gold rush ghost hunting. Earlier in the night, one strange encounter had already occurred, whetting his appetite for more.

Around 10:00 p.m., he crossed the narrow steel Mt. Murphy Bridge. In his hand was an EMF meter. Able to capture the slightest changes of electronic magnetic fields, it had remained quiet during most of his exploration—that is, until he passed the Bekeart Fun Shop. Lights of varying colors skipped across the monitor. This indicated the large presence of something supernatural. The identity of the person or many persons still remains a secret.

On the large expanse of meadow several yards from the park's visitors' center, there appears, at a distance, to be a ramshackle pile of stones and boulders. Walk closer, and the dilapidated heap transforms into granite remnants of three walls, some containing windows with iron bars. These are

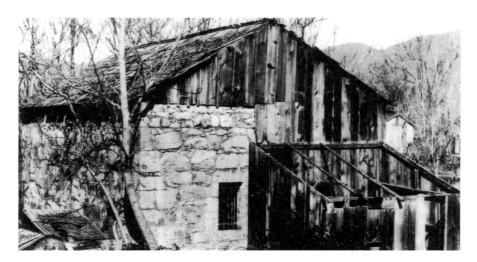

Ruins of Coloma Jail. *Courtesy of California State Parks, 2014.*

the remains of the Coloma jail. Built in 1856, it replaced the town's initial log cabin jail at a nearby location.

Squabbles between miners over claims, national pride or even the affections of a woman were common. After a night or longer of incarceration, most prisoners emerged with cooler heads. Some, however, left to have their necks stretched at the end of a rope for heinous crimes.

As early as 1852, despite the sheriff's pleas, vigilantes stormed the jail to hang two men just outside its walls. Other murderers, such as the lovelorn Jerimiah Crane and the brutal Mickey Free, spent their last days in the earliest Coloma jail prior to their hangings.

The ghosts of Crane and Free are at the haunted Pioneer Cemetery. Near the rock rubble of the old jail, someone else hangs out. Legend says that a prisoner, name unknown and unable to handle imprisonment, ran his belt through the bars of the cell window and committed suicide. Could the sounds of desperate weeping, heard when the park is not packed with visitors, be from that poor soul contemplating his final act over 150 years ago? About the same time, the structure was abandoned to be replaced by Coloma's third jail in less than 15 years.

Time weathered the lumber and stones. In 1879, a number of the boulders were used to construct the foundation of Robert and Louisa Chalmers's Vineyard House. With the house's ensuing history of tragedy and stories of various hauntings, it has been suggested that negative energies had adhered themselves to the stones from the old jail and cursed the Chalmers.

Annually on January 24, the Marshall Gold Discovery State Historic Park, where the Argonaut Restaurant, the blacksmith shop and other buildings are located, holds its Gold Discovery Day. During the 2014 celebration, I entered the blacksmith shop to hear the smithy speak on the craft during the nineteenth century. With two cameras in hand, I began to shoot a video with one. I shortly realized the image was very jumpy and a bit unfocused at the bottom. Snapping a couple quick shots with a simple digital camera, I was amazed later when I downloaded them onto my computer. Close to twenty different orbs of all shapes and sizes were found floating around.

Emmanuel Church, built on consecrated ground, housed one of California's earliest congregations of Episcopalians and Methodists. Just two years after the discovery of gold less than one mile away, citizens of the burgeoning Coloma formed two churches. Five years later in 1855, the churches' parishioners joined forces. Their goal was to create one sanctuary on the hilltop overlooking Sutter's old mill along the American River's South Fork. In the 1860s, it is noted that the Reverend C.C. Peirce conducted

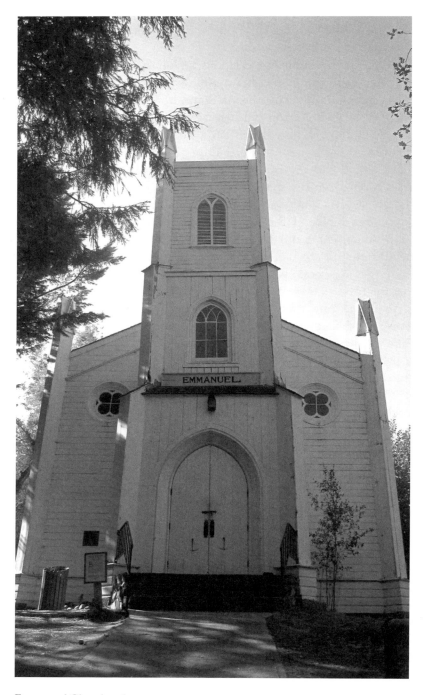

Emmanuel Church today.

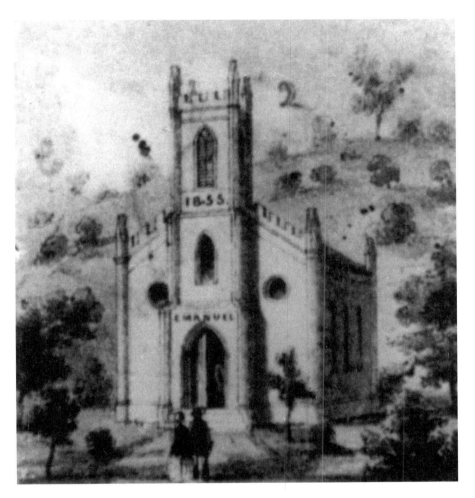

Old print of Emmanuel Church. *Courtesy of California State Parks, 2014.*

monthly services every first and third Sunday evening. As the early Mother Lode's populace faded away with the disappearance of placer gold, so did the congregation. Regular services ceased in the early twentieth century.

Emmanuel's Gothic-style tower still pierces the sky among tall trees. Visitors continue to walk around its grounds, noting the building's interesting woodwork. Weddings and special events can be booked at the old church.

Historic Holiday Homes, a 2013 event, offered the rare opportunity to glimpse into Coloma's past by visiting twenty buildings typically closed to the public. At Emmanuel Church, it also provided a strange supernatural tale.

Several days prior, a lone volunteer busily decorated the front pulpit area with artificial poinsettias and candles during a quiet afternoon. The only noise that punctuated the silence was some creaking, but being focused on her task, she gave it little thought. It was attributed to rats and mice that sometimes worked their way into the church sitting out in a field.

The volunteer changed her mind when the air surrounding her suddenly electrified. The charge was weighty, fuzzy and warm, like when covered by an electric blanket.

The increased squeaking of the church's wooden floorboards and addition of tapping made her realize it was not caused by invading vermin or her own footsteps. Although sufficiently creeped out, she continued working. The noise moved from near her to the back of the church where an old organ stood. As the atmosphere became heavier, she escaped out the front door for fresh air.

Upon her return, the feelings returned but without any sounds. Determined to finish her work quickly, she stood at the back of the church to gaze at the decorations. She was not alone.

She felt the distinct presence of someone next to her but not anyone intent on causing her harm. Instead, she had the feeling it, too, was checking out the holiday embellishments. While no phantom voiced an opinion on her creativity, the battery-powered candles sent a message from the beyond. They blinked on and off in an irregular rhythm.

Although the volunteer never identified her spirit filled with Christmas spirit, at the top of her list was James Marshall, whose funeral service had been held at Emmanuel Church in 1885.

CHAPTER 31

THE ARGONAUT

Coloma's Main Street once buzzed with constant activity. Treasure seekers from around the globe descended on the place where gold had first been found by James Marshall. Their hope to court Lady Luck materialized for some, yet many others were left with only the dream. So determined were they in their golden pursuits that few calculated how much living in a gold camp could cost them.

Eggs ranged between one to three dollars each, while a lack of laundry services made buying new shirts, imported from China, the reality of survival in Coloma. Gradually, others discovered the true way to riches was not to labor in the gold fields. Instead, providing the services miners required brought in the money.

One service provider was Charles Schulze. He came as a miner and before his death held other occupations like blacksmith, teamster and mason. By 1886, he added hotelier to his list when he inherited the Sierra Nevada House, once owned by the ill-fated Robert Chalmers.

By 1916, as a respected member of the community, which was now considerably smaller than during its heady gold rush past, he built a house on Main Street. It was for his daughter Daisy, who often visited. After it passed from the Schulze family, the house became the Argonaut and has served as a coffeehouse and restaurant for several decades.

One past owner was Sydney Bartlett. Before she purchased the building, she knew that a spirit resided there. Previous owners Debbie Zemanek and Silvia Hlavacek told stories of a washerwoman named Alice who could be

The Argonaut.

found still haunting the place. Her antics bordered on the annoying as she would manifest herself by walking with heavy footsteps in the front part of the building when employees were in the back. By the time they rushed to the front, Alice would have vanished.

A local psychic advised them of Alice's occupation, her large size and the fact that, in life, she had often been overlooked by others. Being snubbed during her lifetime had made Alice determined to gain recognition to ease the loneliness in her afterlife.

Bartlett distinctly remembered one hot midsummer day when she closed the Argonaut. With keys in her hand, she walked around the building, away from its side nearest the American River to her car parked off Main Street. There she realized she had forgotten something.

As she pushed open the side door, her nose was assaulted with the strong smell of lavender. Once used heavily in the washing and storing of freshly cleaned laundry, Bartlett knew the spirit of Alice was active in the Argonaut. The accompanying rush of ice-cold air confirmed her suspicions. An unhappy spirit was nearby.

Rather than react in fright, she chose to speak to the long-dead laundress in a cordial manner: "I told her I was very sorry for disturbing her but I had forgotten something and was not there to bother her. I wanted to be her friend and not an enemy."

She never felt threatened or afraid. After she retrieved what she had previously forgotten, Bartlett left the shop. Before shutting the door, she bid Alice goodbye.

Bartlett's friendliness and recognition must have worked, as she reported that she never had the pleasure of meeting Alice again. Years later, she still remembers her spirited experience.

Another phantom has been known to appear at the Argonaut. A stout man described as having gray hair and wearing overalls has been sighted looking out the windows. Slowly, he fades away without revealing what he is staring at. One thought is that, like Argonaut patrons of yesteryear and today, he simply is enjoying the beautiful scenery of the Coloma Valley that surrounds it.

CHAPTER 32
SIERRA NEVADA HOUSE

At the corner of Highway 49 and Lotus Road sits the Sierra Nevada House. While the maroon letters of the front gate's wooden sign say "Est 1850," this building is neither the original nor in the first location. Many people confuse it with the earlier one with the same name. Hailed as one of California's finest establishments, the mid-nineteenth-century hotel reigned supreme on Coloma's Main Street. Although there are two different buildings, it is evident from tales at the latest Sierra Nevada House that all the original hotel's ghosts received their change of address notices.

In 1850, Coloma still remained a top destination for many Argonauts and others. The quest for riches brought them to pan the American River's waters, mine deep in hillsides or acquire wealth as shopkeepers, gunsmiths and hoteliers. Robert Chalmers, the respected yet doomed businessman, bought the Sierra House from Philip Schell. Under his ownership, the hotel expanded and flourished.

Sold before his 1881 death, the hotel remained a central part of Coloma's dwindling community until it burned down in 1903. It became a silent movie house until fire claimed it again in the mid-1920s. Rebuilt in the early 1960s, it remains a popular place for locals, hundreds of summertime whitewater enthusiasts and spirits of the dead.

Two motorcycle enthusiasts, Ed and AJ, roared down Highway 49 from Auburn for a few hours of fun on their Harleys in late December 2013. Over coffee and cranberry-orange cake at a local gathering spot, the Sierra Rizing Café, they spoke about an odd dinner several years prior. Along with

Above: Current Sierra House.

Right: Illustration of Robert Chalmers.

their spouses, they were enjoying dinner when the table's candle suddenly stopped burning. It seemed strange as the wick was long. Pulling out his lighter, Ed relit the candle and continued eating. Before the entrees were finished, the candle's light again extinguished itself. Laughing as he relit it for the second time, Ed's amusement stopped abruptly. While still in his hand, the candle went dark for the third time.

He said, "I felt like someone was next to me blowing it out."

AJ remembers telling their waitress about the peculiar experience. Unfazed, she brought them a new candle with the words, "Maybe Isabelle was responsible."

Former employees have told tales of glasses moving across the bar without the benefit of human hands. The action has also been attributed to the elusive Isabelle.

Local legends say she was a prostitute, possibly even a bordello's madam. Despite her many clients, her heart only belonged to Pete. As a prospector,

he would leave her for months while seeking golden rewards. Then came the time when he never returned. Although her desperate inquiries to locate Pete or discover details of her lover's whereabouts turned up nothing, Isabelle refused to lose hope. She would keep her bedroom door unlocked.

Guests staying in room four, said to be Isabelle's, have reportedly found their door open, despite having locked it earlier. Anyone curious to Isabelle's appearance has been told to stand by the large ornate mirror in the Sierra Nevada House's private party room. Her image, stunning in grand Victorian garb, has been seen gazing out. Perhaps she is still looking for Pete.

CHAPTER 33
HANGINGS IN COLOMA

Along Cold Springs Road, less than a quarter from where it ends at Highway 49, lies Coloma's Pioneer Cemetery. Wind passes through the tangled branches of the ancient oak trees shielding centuries-old graves. Occasionally, voices, absent of bodies and forlorn in tones, are heard speaking along the top ridge. Some say it is just the creaking of old wood. Others know the sad declarations belong to the four men hanged there as punishment for their evil deeds.

"What Was Your Name in the States," a popular song throughout gold rush towns and mining camps, alluded to the drastic changes some Argonauts and others made en route to California. New names were created, as well as life stories. One could suddenly become a foreign aristocrat, an Eastern heiress or a traveling minister. The existence of wives, husbands and children were forgotten as miles, whether by land or sea, separated families.

Jeremiah "Jerry" Crane came from Kentucky. Middle-aged with a scholarly demeanor, he was called "Doctor" by the locals of Ringgold, near Placerville. Trading his teaching skills for room and board with the Newnham family, their eighteen-year-old daughter, Susan, soon swooned romantically under the older man's ardent attention. Declared vows of love were followed by plans for a future together—until word arrived of Crane's wife and four children still in the Bluegrass State.

Banished from the Newnhams' home and barred from further contact with Susan, Crane's refusal to accept the situation lead to tragic circumstances. He convinced his young lover that their true happiness awaited them in the

Hilltop where Jerry Crane and Mickey Free were hanged.

afterlife. In the intense afternoon heat of August 5, 1855, by her parents' house, Crane shot Susan in the head. The first shot and the next two, fired in rapid succession, failed to kill her immediately. Mortally wounded, she was laid out on her bed by her older suitor. Their botched murder-suicide pact next had Crane running into the nearby woods.

His concern over Susan made him return the next day. He was covered in a mixture of his and the dying girl's blood. He told the gathering crowd that after shooting the object of his affections, he had attempted suicide twice. A dull knife proved futile in slashing his wrists, and the revolver had jammed after being pressed to his forehead. As the masses grew into a vigilante mob hell-bent on rapid revenge, Crane told them he did not like the idea of hanging, but if a revolver could be lent to him, he would gladly show them all how a Kentuckian could die.

His request was denied and a rope found. It was only due to fast-acting and talking El Dorado County sheriff David Buel that Crane was removed alive and hauled to the county jail in Coloma. Upon his young mistress's death five days later, a murder trial was set. Impassioned pleas explaining the need to kill Miss Newnham in order to live forever in love did not sway the jury. Crane was sentenced to die by hanging.

It was to be a duet in death as Mickey Free was also scheduled to swing on a sturdy rope the same day. Like Crane, Free had been convicted of murder. Unlike the former Kentuckian, the Canadian of Irish ancestry was a serial killer.

A thug with little remorse for his nefarious actions, he was known for killing a man simply for not leading him to a rich vein of gold. Working alone or with equally vile partners, he discovered that great profit came from robbing gold directly from the miners and traders. His reign of terror covered several counties, but his favorite domain was between El Dorado County's towns of Clarksburg and Coloma. Regularly, he chose immigrants as his victims.

Unfortunate Chinese and Europeans suffered the most at his sadistic hands. After being caught mutilating some after killing them and then a white man, Free's trial in Coloma was swift. The sentence came even quicker. Mickey Free received an autumn date with the hangman.

During the mid-nineteenth century, throughout the West, a hanging was typically a big event. Coloma was no exception on Sunday, October 26, 1855.

As for the execution the year before of murderers James Logan and William Lipsey, curious people came from as far away as Sacramento, almost fifty miles away. Arriving via horseback and stagecoach, the throngs filled Coloma's hotels and restaurants to capacity. The air was thick with a macabre festive atmosphere. By 1:00 p.m., over five thousand spectators carpeted the hilly terrain just north of Main Street.

Before receiving his rope necktie, Crane read a self-composed poem from the gallows.

> *Come friends and till other, I bid you adieu.*
> *The gates are open to welcome us through.*
> *No valley or shadow do I see on the road.*
> *For the angels are waiting to take me to God.*
> *My body no longer in spirit shall l aim.*
> *This day I am going from sorrow and pain.*
> *The necklace and gallows will soon set me free.*
> *Then oh joyous and happy my spirit will be.*
> *I'm going, I'm going, to the land of the free.*
> *Where all love each other, and ever agree.*
> *I'm going, I'm going, I'm going. I'm gone!*
> *Oh, friends and relations, it is done, it is done!*

At the end of the poem, Crane loudly declared, "Susan, receive me. I will soon be with you."

During the recitation, a pile of fresh peanut shells grew near Free's feet as he nonchalantly popped them into his mouth. As the crowd looked on, some

witnesses reported that he entertained everyone with a fast-moving jig and spirited song before he was placed over one of the gallows' trapdoors.

In 1929, ninety-nine-year-old James Sampson Russell, a witness to the dual hanging, recalled the thug's final words in a newspaper interview:

> *"What time is it?" asked Free of Sheriff David E. Buel.*
> *"Time to hang you, Mickey Free," came the lawman's reply.*

Shortly before 2:00 p.m., both bodies swung slowly as the sound of straining ropes kept a steady rhythm. What happened afterward remains a point of mystery.

Modern-day enthusiasts of local history offer several theories. An employee from the Marshall Gold Discovery State Historic Park declared that the mortal remains of Crane and Free lay buried in unmarked graves somewhere in the Pioneer Cemetery. If that is true, they joined Logan and Lipsey, who, according to a Sacramento newspaper, were buried at the foot of a knoll of hilltop trees. Others claim Crane's body was interred in Ringgold, close to Susan Newnham's grave.

Perhaps by standing quietly under the cemetery's grove of gnarled oaks on the high ridge, the answer can be heard in the passing breezes.

CHAPTER 34
COLOMA'S PIONEER CEMETERY

Pulling into the small driveway of the Pioneer Cemetery in Coloma, most people first notice its serenity. Across the rippling hillside, oak trees, singular and in groves, form towering sentries over dozens of silent graves. A sign at the front gate reminds visitors to respect the early settlers who are buried here. Some slumber eternally under simple stones. Others are under marble and granite memorials of Victorian grandiosity complete with cherubs, scrolls and floral displays. As the cemetery is still in use, modern-day tombstones are etched with twentieth and twenty-first-century names and dates as well.

However, according to some residents and visitors, there are frequent breaks in the peacefulness, not from the living—but the dead.

"You're going to write about the lady in burgundy, aren't you?" asked a former El Dorado County sheriff. Under confidence of anonymity, he proceeded to talk about sporadic reports that came in from astonished motorists, bikers and hikers traveling along Cold Springs Road.

A majority of the encounters begin with a tall, youngish woman standing on the side of the road and frantically gesturing passersby toward the cemetery. Her hair is jet black, parted in the middle and worn in a severe bun typical of the mid-nineteenth century. Like her hairstyle, the dress she wears also comes out of the Victorian age. The material's color is a luscious claret wine. When the wind blows, the dress's floor-length hem billows out, giving her a bell-like appearance.

In addition to the sightings along the roadway's narrow shoulder, the specter has been spied inside the cemetery standing on its eastern hill. Others

Chalmers family plot at Pioneer Cemetery.

have witnessed her standing by a set of graves belonging to the Schieffer family. This is where the mystery about the phantom's identity deepens.

Four-cornered and topped with a soaring urn-like edifice, the gravestone only has three names engraved on it. From the dates, it appears that Charles Schieffer, who passed away in 1864 at the age of forty-three, was the father. Next to him lies his young son who died in his second year of life in 1861.

That same year, tragedy turned to joy when a daughter was born. She survived to adulthood and now rests with them under an engraved olive branch–toting dove and the heart-warming epitaph of "Sleep on dear May. You are not forgotten."

Each of the children are immortally listed as only belonging to Charles Schieffer. However, who was their mother, and where is she? Nearby, a simpler granite gravestone with a classic curved top bears the names of an Eliza Taylor and Catherine Schieffer. Taylor, born in 1842, died in 1904. Schieffer's dates were from 1862 to 1916, making it possible that she was a sister to May and her ill-fated brother. It would explain who was mourning May on her death.

Some think Eliza is the lady in burgundy. Her waving to strangers acts as a lure into the cemetery. Being found near the Schieffers might be her only way to communicate that she, too, was part of this family. Photographs by paranormal enthusiasts show two small greenish lights hovering to the side of May's grave while a large and brilliant ball of white light envelopes the top.

When at the grave site on chilly days, people have felt a sudden warmness. Described as the feeling of being covered with a light blanket or having a sunbeam warm one's shoulders, it would seem to reflect a mother's loving ways.

Cold spots have also been experienced by those visiting the Pioneer Cemetery and those simply walking past it. Back when the Vineyard House was still one of El Dorado County's premier restaurants and accessible for experiencing unexplained phenomena, a family took a post-dinner stroll in the early 1990s. The mild night turned suddenly nippy when they neared the cemetery directly across the street.

A thrill accompanied the chill when the normally noisy crickets stopped chirping and a mist appeared in the hilltop trees. A few psychics thought it might be the Lady in Burgundy. Others say no, due to the fact that the hilltop was also the place where both Jerry Crane and Mickey Free were hanged for murder. Crane, a married teacher, had killed his teenage student under the self-declared throes of living together in love after death. Caught stealing rabbits and old ladies' church money as a mere boy, Mickey Free had grown into a violent man who looked on killing others as a sport. The location of their unmarked graves still remains unanswered, but it is thought they rest under the higher elevation oak trees where the scaffold stood.

Among the renowned individuals buried here is Robert Chalmers. As the original owner of both the Sierra and Vineyard Houses and a vintner who increased his wife's agricultural inheritance, his sad story is known to many ghost hunters. Insane and blind, he was chained by his wife, Louisa, in the

Vineyard House's cellar. Distressed screams heard from his centuries-dead throat have been heard repeatedly. Some agonized cries have even reached his grave, just several hundred yards away and within view of his former home and prison.

Compared to the opulence of neighboring headstones, the four-planed red granite one over the Chalmers family is Spartan. Only names—no dates—adorn it. This makes it easy for many to mistakenly assume the Louisa under the carving is Chalmers's infamous third and final wife. In fact, it was their daughter.

Elsewhere in the Pioneer Cemetery, Louisa Weaver Allhoff Chalmers Hardie resides for eternity next to her first husband, Martin Allhoff, under a simple brass plaque. Dead by his own hand, Allhoff, his wife and Chalmers have been identified as additional unsettled spirits who are seen as mists swirling across Cold Springs Road to the place where their vineyards once flourished.

In Coloma, every season brings plenty of high spirits.

GEORGETOWN

THE AMERICAN RIVER INN

Georgetown's American River Inn's history perfectly mirrors the intoxicating ups and devastating downs of a nineteenth-century gold rush town. Check in and find a few old guests still there.

First built as a private home in 1853, the structure was soon bought and turned into a hotel and stagecoach depot. Its name changed almost as frequently as the owners. It went from the Orleans Hotel to the American Hotel and then the Ceque, although by that point, everyone continued calling it the American.

During parts of the nineteenth and twentieth century, it served as a boardinghouse. When miners lived there, they did not have far to go to work. Directly under the American Hotel was, and still is, the Woodside Mine. The most famous gold nugget extracted weighed almost eight pounds.

Tragedy struck when portions of the mine collapsed. An undetermined number of miners remain buried near the hotel. Some modern-day people claim to have heard disembodied voices of frantic yelling near the inn along Orleans, Church and Harkness Streets. Accompanied by the sounds of desperate digging with pickaxes and other tools, it is believed that the trapped miners, unaware they are dead, still seek their freedom. The best time to experience this is on a quiet night in Georgetown, not when the small mountain town is busy with summertime's whitewater enthusiasts or Jeepers hitting the nearby Rubicon Trail.

The early inn miraculously escaped the 1856 inferno that swept through downtown's rows of frame buildings. Four decades later, unfortunately,

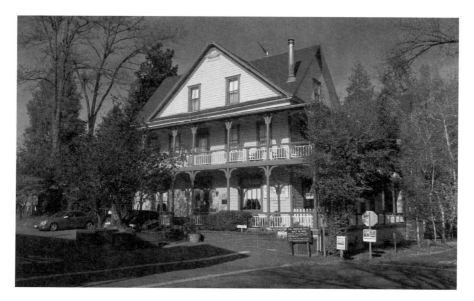

The American River Inn.

another fire completely consumed the structure. Luckily, no lives were lost. Quickly rebuilt on the same site, the inn soon welcomed long-term residents until the 1970s. Within a decade, one of El Dorado County's oldest accommodations transformed into the American River Inn and the attractive bed-and-breakfast it remains today.

Its antique furnishings and vintage memorabilia charm not only the inn's paying guests but also one who has refused to leave for the past two centuries. Paranormal experts report that his name is Oscar. Seen as an older, grizzled miner, local lore praised his hard work ethic and good luck. He was a survivor of the Woodside Mine. However, when it came to love, Oscar was far from fortunate.

His lady of choice had a profession that went by many names: soiled dove, lady of the night and whore. Although her actual name is lost to the ages, it is thought she was considerably younger than the miner. So strong was his adoration for the prostitute that he overlooked her profession and the time she spent with other clients. His patience, nonetheless, was short when unsavory comments were made by a dissatisfied customer.

Hot words were uttered, tempers grew short and, in few minutes, gunshots rang out. Oscar lay crumpled and lifeless as rivulets of his blood stained the front steps of the American Hotel.

Death does not separate Oscar from his romantic notions. Guests in room 5, one the American River Inn's honeymoon suites, have awakened to find his entity in the room. To ensure that his presence is known, it is said he turns on the lights. His entrance is always the same: through the lace-draped balcony door. Rather than being scary, the old miner is cordial. He smiles while walking toward the front door. Ever polite as his footsteps fade away, he also extinguishes the light.

PIONEER CEMETERY IN GEORGETOWN

O ff Highway 193, less than a half mile from Georgetown's Main Street, a soaring, curved iron sign beckons to the curious. A stroll through the terraced Pioneer Cemetery in Georgetown combines history with the unexplained.

Among the flood of humanity climbing the mountains in pursuit of gold, some found death instead of riches. Thomas Warner is thought to be the first Argonaut buried here in 1848. Unfortunately, his marker, probably created from wood, long ago rotted away.

The honor of the first identifiable grave belongs to an Issac Green, who died on August 4, 1850. Sadly, as the population of the town heralded as the "Pride of the Mountains" increased, the number of the cemetery's eternal inhabitants also grew. Their tombstones marked the thousands of miles many traveled to reach the Mother Lode. Switzerland, France and Italy were just a few of the countries of origin for these miners.

Many sleep under exquisitely carved marble and rose quartz gravestones spiraling to the heavens and topped with crosses, spheres and even an eagle. Other stones, like Peter Millet's, lay alone flat on the earth with sorrowful angels keeping perpetual watch. Multiple members of families, like the Giudicies and the Irishes, rest together in large plots.

The most heartbreaking are the small signs saying "unknown" that dot the cemetery grounds. The modern-day dedication of volunteers has placed them where a nameless body lays. Could these souls, whose identities are forever lost to time, rise from their graves on occasion and present themselves as orbs?

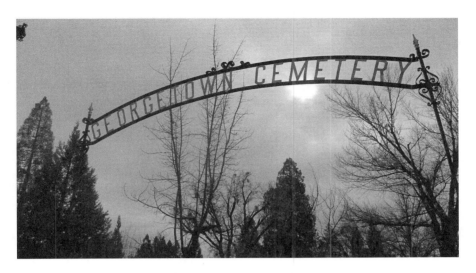

Georgetown Pioneer Cemetery.

This is what a couple amateur ghost hunters from Hanover, Germany, thought. Marianne Berger and Hans-Georg Dankers grew up hearing tales of the California gold rush. Enamored for years with the history and romance of the Old West, they decided to see it for themselves in early February 2014. Equipped with recording devices and cameras, they especially wanted to meet the spirits of prospectors as they toured old buildings and cemeteries from San Francisco, Sacramento and into El Dorado County.

After taking our ghost tour, privately they shared their experiences, one of which was in Georgetown's Pioneer Cemetery. The two had already been by the neighboring town of Greenwood's cemetery looking for the reported mysterious mists. When none appeared, they drove five miles farther east to Georgetown. In a very dry winter, rain had come to Northern California that day. Knowing that wet weather can energize spirits, they trudged around in a wet muck of leaves and mud with anticipation. Unfortunately, the two received no readings on their EVP in the cemetery's western portion.

Rather discouraged, they walked to the east side, where they found the grave of a fellow Hanoverian. William Barklage, born in the then Kingdom of Hanover in 1840, had died in the Sierra Nevada seventy years later. The grandeur of his tombstone, featuring extensive carvings and four Doric-capped columns, indicated the great wealth he and his brother G.H. had acquired in mining, mercantilism and timber following their 1858 arrival in California.

"Wie geht es Ihnen?" asked Hans-Georg, inquiring on the welfare of the German, dead over a century. As he continued speaking in Barklage's native tongue, his partner snapped photos.

In the dreary drizzle of the daytime, an oval shape appeared first about a foot above the ground. The next three photos showed it moving up and closer to Dankers as he continued speaking. Then it simply disappeared. Had it become bored with the conversation?

Talk from the dead actually occurred in the newer part of the cemetery in the twenty-first century as well. Nearby Garden Valley was the home of Al Teurman for over fifty years. He was a World War II veteran and recognized hero, according to his grandson Devyn. Having lived with the old man since childhood, the now twenty-something cook remembers him as a great guy.

Upon the elder Teurman's death in 2006 at the age of ninety-six, his family was unable to find the funds to erect a gravestone. Several years later, the old man's displeasure at not having a permanent memorial to his life became known—loudly.

A number of people passing the cemetery reported hearing stern words coming from the newer section bordering Clark Street. It is on the lower level with only a chain-link fence and gate to separate it from the roadway. Curiosity led some to investigate a particular patch of grass.

"Get me a headstone" was the command uttered into the air by no one with a human form.

Most listeners walked away, convinced it all had been in their imaginations, but one woman steeled herself beyond her own disbelief and reentered the cemetery.

This time the phantom voice was less stern and more pleading: "I need a headstone."

After hearing the plaintive request again, she decided to forego her fear and feelings of disbelief and foolishness. Instead, she contacted the man responsible for the graveyard's upkeep, who eventually contacted Deyvn Teurman.

Incredulous at first, the young man soon accepted his grandfather's ability to reach out from beyond the grave. Plans for a simple stone are underway. Al Teurman must know, as he has been very quiet lately.

CHAPTER 37

MURDER OFF SLIGER MINE ROAD

In the heady days of the gold rush, murder was rampant in thought, word and occasionally deed.

As the world had rushed into northern California, it brought with it a sense of urgency. Mostly male prospectors splashed into rivers and creeks or carved away at the waterways' shorelines. Others dug pits and ditches out of hills and around boulders, all in a desperate search to locate a rich golden vein before anyone else.

The South Fork of the American River had yielded the initial find, so many flocked there upon their arrival to the gold fields. The location, being overcrowded and overworked, caused a large number of Argonauts to trek farther north and beyond.

Miners often worked alone. Such independence guaranteed the biggest profit. It also left a person exposed to falling victim to marauders and murderers. Unwilling to submit to the unrelenting toil that could yield little to no gold, criminals instead rode across Gold Country's foothills. Their perfect scenario was to come upon a lone miner and grab his cache. Understandably, reluctance to yield this cache was high on the part of the hardworking miner. Often, obtaining it required murder.

In the wildness of the untamed West, such felonies usually went undiscovered. This has left a raft of unsettled spirits roaming El Dorado County. Georgetown's Bob Cotenas is certain that he and his cousin Calvin met at least one of them, and the spirit was far from happy.

Panning for gold.

Sliger Mine Road is several miles outside of Georgetown. Once a three-hundred-feet-deep mine, it had produced over a quarter million dollars of gold starting in 1864. Nowadays, people use it as an access to the river.

In 1982, the two decided to try their luck in looking for gold on a sunny afternoon. Cotenas remembered his cousin was very precise about where he, Cotenas, stood in the water.

"Pan right there" was his exact command.

After a few minutes, Cotenas became aware of how suddenly quiet everything became. No longer could he hear the breeze moving through the leaves of cottonwood and alder trees. Bird song was silenced, as was the water passing over boulders and lapping against the shore. Surrounded by a trio of stone-filled hills, he felt he was being attacked from one side. Nothing marked his body, yet he physically felt blows. His voice gone, he was unable to attract his cousin, only a few yards away. For just an instant, he was given momentary relief before the next attack hit. This time, he was conscious of being assaulted from a different position and by three people.

As quickly as it had started, the terrifying phenomenon quit.

By now, Calvin splashed across the river water to Cotenas's side. Recounting his almost unbelievable experience, his cousin's reaction shocked him.

"That is exactly what happened to me!" his cousin cried.

Over thirty years after his encounter, Cotenas is still certain the two men had been temporary supernatural witnesses to a killing from the past.

Given the suspected high number of murdered miners whose unclaimed bodies decayed into the gullies, knolls and waters across the Gold Country, there is no way to identify the tortured soul's identity. Perhaps showing the living his centuries-old murder near present-day Sliger Mine Road is his sole way to find comfort from beyond.

Terry's Pizzeria and Grill

For almost a decade, people looking for great pizza, burgers or other comfort foods have headed to Terry's Pizzeria and Grill off Highway 193, just yards from the heart of Georgetown. It appears when ghosts from the town's past want to do some spirited spooky stunts, Terry's is one of their favorite spots.

Although the building was only constructed in the 1960s, entertaining entities from centuries past does not surprise Yolande Hall. She owns the restaurant with her husband, Terry, and their daughter, Meghan. Its location directly across from the Pioneer Cemetery gives credence to hauntings coming from the place where burials have occurred since 1849.

Yolande expands on that paranormal theory, saying, "I heard a bordello once existed on this site during the gold rush. They might be buried nearby as well."

Places of pleasure were occupied by more than just lusty miners. Often, children of the working girls ran about the bawdyhouses. This explains what a former tenant regularly experienced. Every morning, alone in the closed restaurant's kitchen, the cook rolled out dough and cut it into cookies. Before the trays were baking in a hot oven, she felt the overwhelming presence of youngsters gathered around her.

Although never seen, paranormal energies, perhaps excited by the lingering and beyond-the-grave memory of sweet delights, were obviously heightened. While the ghosts never took a bite from a warm cookie, they did express their gratitude by patting the baker's shoulder frequently.

Specters at 6274 Highway 193 tend to stay in the kitchen area. That is where the Halls and their employees have heard the word "Mama" repeated over and over again by the voice of an invisible little girl. The pleasing aroma of cherry pipe tobacco also drifts about.

Not every spook has been a happy one, unfortunately. Knives and other objects have flown across kitchen counters and tables only to crash into sinks with ferocious force and without warning.

Wintertime tends to be the best season for the restaurant's spirited activity. This makes sense to paranormal experts, as it is Georgetown's rainy season and fewer tourists travel up the mountain roads to visit. Spirits still love a good drink, especially the water of the Sierra Nevada.

CHAPTER 39
THE GEORGETOWN HOTEL

Like a bridge between the town's vibrant gold rush past and the slower pace it now enjoys, the Georgetown Hotel has something for all its guests. Some appreciate its Main Street location, vintage furnishings and authentic Old West saloon patronized by locals and visitors. Others come for the odd creaking and apparitions of all ages, the phantom smell of tobacco and, of course, Myrna.

It was during the giddy days of 1852 when G.H. McKinney built the first Georgetown Hotel. Forty-four years later, it was rebuilt and survived the massive fire of 1897 that destroyed much of Georgetown. Several people were killed along Main Street when barrels of stored gunpowder exploded. The hotel's ownership changed frequently over the next few decades. It mirrored the town's fortunes as they faltered and rallied, such as in 1928, when miners from the Eureka Woodside Mine booked it to capacity.

Employees and patrons, past and present, have reported strange happenings through the years. A ball bouncing along the hallway, followed by a delighted giggle, has caused guests to open their doors expecting to see a happy child—a *living* happy child. Instead, some get a fleeting glance of a young boy, about ten years old. Dressed in Victorian-era clothing of woolen, knee-length knickerbockers held up by suspenders, he disappears before anyone can catch him.

At the bottom of the stairs, some have witnessed a man seated on the steps. His name remains a mystery. That is not the case with the entity called Myrna whose spirit haunts room 5.

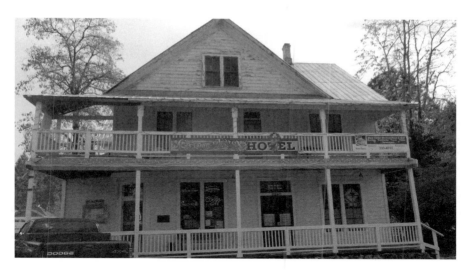

The Georgetown Hotel.

Exact dates have been lost to written facts, but local lore acknowledges her as the woman at the heart of Georgetown Hotel's most tragic story. Myrna was one of the thousands of prostitutes who followed Mother Lode miners from strike to strike. No one knew what caused a particular patron of her services to become jealous. Perhaps promises of true love had been offered, only to be rebuffed or broken. The reason Myrna was killed and her actual dates of birth and death also remain unknown, but legend says a vicious fight erupted upstairs in the hotel. It came to a sudden stop when the prostitute was thrown screaming off the second-story balcony and landed dead from a broken neck. Over a century later, guests in the room know when the poor wench is nearby. The drapes move slightly without a breeze from an open window. In the bathroom, water turns on and off without any human contact.

In recent decades, Georgetown local Bob Cotenas has been hired to perform occasional duties like painting and fixing the pipes and windows, usually during the off-season of wintertime. His memories include creaking stairs when he was the building's only occupant. Another experience was the frequent aroma of tobacco smoke. It wafted in and out of rooms and along hallways where no one was found.

Checking in at the Georgetown Hotel brings a mix of history, mystery and hauntings throughout the ages.

SELECTED BIBLIOGRAPHY

BOOKS

Barden, Cindy, and Maria Backus. *Westward Expansion and Migration, Grades 6–12*. Greensboro, NC: Carson Dellrosa Publishing, 2011.

Borthwick, J.D. *Three Years in California*. London: William Blackwood and Sons, 1857.

Buffum, Edward Gould. *Six Months in the Gold Mines: From a Journal of Three Years Residence in Upper and Lower California, 1847–1849*. Philadelphia, PA: Lee and Blanchard, 1850.

Carr, John. *Pioneer Days*. Charleston, SC: BiblioLife, 2009.

Dillinger, William C. *The Gold Discovery: James Marshall and the California Gold Rush*. Sacramento, CA: California Department of Parks and Recreation, 1990.

Ferguson, Marilyn. *A Glimpse of El Dorado: The County that Made California Famous*. Placerville, CA: El Dorado Chamber of Commerce and Heritage Association of El Dorado County, 1976.

Hawkins, Charles Watson. *The Argonauts of California*. New York: Ford, Howard & Hulbert, 1890.

Howe, Octavius Thorndike. *Argonauts of '49*. Cambridge, MA: Harvard University Press, 1923.

Moser-Flynn, Halmar. *El Dorado County Historic Places of Interest, Myths and Legends*. Placerville, CA: Heritage Association of El Dorado County, 1994.

Nadeau, Remi. *Ghost Towns & Mining Camps of California: A History & Guide*. Santa Barbara, CA: Crest Publishing, 1999.

News Notes of California Libraries 12, nos. 1–4 (January–October 1917). Sacramento, CA: California State Printing Office, 1918.

Norton, Henry K. *The Story of California From the Earliest Days to the Present.* Chicago, IL: A.C. McClurg & Co., 1924.

Royce, Josiah. *California.* Boston, MA: Houghton Mifflin, 1897.

Sanborn, Margaret. *The American River of El Dorado.* Boston, MA: Holt, Rinehart and Winston, 1974.

Schlappi, Jane. *A Walk Through the Gold Rush: A Historical Tour Guide.* Placerville, CA: Gold Rush Publications, 1987.

Sederquist, Betty. *Images of America: Coloma.* Charleston, SC: Arcadia Publishing, 2012.

Sioli, Paolo. *Historical Souvenir of El Dorado County.* Oakland, CA: self-published, 1880.

Starns, Jean E. *Wealth from Gold Rush Waters.* Georgetown, CA: Word Dancer Press, 2004.

Upton, Charles Elmer. *The Life and Work of the Reverend C.C. Peirce.* Placerville, CA: Self-published, 1903.

A Volume of Memoirs and Genealogy of Representative Citizens of Northern California. Chicago, IL: Standard Genealogical Publishing Co. 1901.

Yohalem, Betty. *I Remember…Stories and Pictures of El Dorado County Pioneer Families.* Placerville, CA: El Dorado County Chamber of Commerce, 2000.

ARTICLES

Bend Bulletin. "Gold Country Beckons." December 22, 2013.

Daily Alta California. December 11, 1858.

El Dorado County Historical Museum Research Room. "Exploring Downtown Placerville" flier, 2010.

Grizzly Bear. June 1912.

Mother Jones. "Keepers of a Lost Language." July/August 2004.

Mountain Democrat. "Around the House with Ann Comfort." December 25, 1941.

———. August 7, 1985.

———. "B&B." December 6, 2002.

———. "Book Shows Placerville Then and Now." February 3, 2014.

———. "California Rambling: Ghost Stories." October 14, 2013.

———. "Calm Ghosts in Georgetown." October 30, 2000.

———. "Convicted of Murder." November 26, 1859.

———. December 30, 1998.

———. "Early Pioneer Made Living Through Gunsmithing." June 30, 2000.

———. "Exploring Marshalls Footsteps on Bayne Road." November 17, 2009.

———. "Fountain-Tallman the Biggest Little Museum in the West." March 9, 2012.

————. "Ghost in Bookstore Likes Teasing Patrons." October 26, 2010.

————. "Ghostly Doins on Main Street." October 26, 2013.

————. "Haunting Stories from the Sequoia." October 27, 2010.

————. January 16, 1925.

————. January 27, 1894.

————. "Man's Remains Found in Fire-Burned Area." December 10, 1992.

————. May 19, 1883.

————. "Mines of El Dorado County." March 5, 2008.

————. "Mysterious Cary House Remains Close to the Action." December 10, 2010.

————. "99-year-old County Resident Honored at Birthday Surprise." May 17, 1929.

————. October 12, 1867.

————. "Pearson Soda Works." April 10, 2003.

————. "Placerville News Co. Family Celebrates 100 Years." July 16, 2012.

————. "Romance Can Be Found in Your Own Backyard." February 13, 1998.

————. "See Real Gold Artifacts." April 13, 2007.

————. "Soda Works Spirits Quiet." October 30, 2000.

————. "'Spirits' on the Menu at Local Café." October 31, 2011.

————. "Tales of Ghosts and Reading Make for Good History." October 31, 2002.

————. "The Devil's Punch Bowl." June 23, 2000.

————. "The Unhappy Romance of Jeremiah Crane and Susan Newnhan." June 16, 2000.

————. "Trial Gets Underway for Fiendish Murder." December 2, 2009.

————. "Wave of Prosperity Is Apparent in Georgetown." September 21, 1928.

Oakland Tribune. August 12, 1962.

Sacramento Bee. "Chinese Transformed 'Gold Mountain.'" January 18, 1998.

————. "Coloma Is One of Our Favorite Haunts." November 4, 1988.

————. "Coloma Sprang from Gold Find." January 18, 1998.

————. "Justice Wasn't Pretty—But it was Quick." January 18, 1998.

————. "Placerville Couple Buy Historic Buildings for Renovation." February 25, 2012.

Sacramento Daily Union. July 9, 1856.

————. June 15, 1897.

————. November 6, 1854.

————. October 27, 1855.

San Francisco Call. January 22, 1898.

San Francisco Gate. "Placerville: Old Hangtown." October 22, 1999.

Santa Ana Orange County Register. "Ghosts Galore in the Golden State." October 30, 1994.

Sunset Magazine. "Coloma, About Those Ghosts…You're Kidding Right?" October 1, 1992.

ONLINE

"The American River Inn." http://georgetowndivide.wordpress.com/2010/02/08/the-american-river-inn-3/ (accessed December 14, 2013).

"The American River Inn." https://www.edcgov.us/Living/Stories/American_River_Inn.aspx (accessed December 14, 2013).

Bartlett, Sydney. E-mail to Linda J. Bottjer. Placerville, February 21, 2014.

"City of Placerville's Park and Recreation Department Historic Resources Inventory." http://www.cityofplacerville.org/civicax/filebank/blobdload.aspx?blobid=6138 (accessed January 4, 2014).

"Coloma, CA." http://www.westernmininghistory.com/gallery-image/641/3986 (accessed February 21, 2014).

"Frances Page." http://familytreemaker.genealogy.com/users/c/o/x/Donald-C-Cox/WEBSITE-0001/UHP-0391.html (accessed March 15, 2014).

"Gold Bug Mine." http://www.comspark.com/eldorado/goldbugmine.html (accessed February 23, 2014).

"Gold Bug Mine." http://www.goldbugpark.org/priest-mine.html (accessed February 23, 2014).

"The Historical Marker Database." http://www.hmdb.org (accessed March 4, 2014).

Huff, Robert. E-mail to Linda J. Bottjer. Placerville, January 17, 2014.

"Kam Wah Chung." http://www.nps.gov/NHL/find/recentdesigs/or/KamWahChung.pdf (accessed March 12, 2014).

"Marshall Gold Discovery State Historic Park." http://www.parks.ca.gov/?page_id=26418 (accessed February 21, 2014).

"Martin Allhoff, Sr." http://www.weeklypioneer.com/2010/02/martin-allhoff-sr.html 11Feb 2014 (accessed February 11, 2014).

"New Owners to Restore Hangmans Tree and Herrick Buildings." http://www.mtdemocrat.com/news/new-owners-to-restore-hangmans-tree-herrick-building (accessed March 22, 2014).

"Pioneer Cemetery." http://www.findagrave.com/cgi-bin/fg.cgi?page=gr&GRid=59035731 (accessed February 11, 2014).

"Placerville News Company." http://pvillenews.com (accessed February 29, 2014).

"Placerville Union Cemetery." http://www.findagrave.com (accessed December 12, 2013).

Selected Bibliography

"Sierra Nevada House." http://www.sierranevadahouse.com/about/history/ (accessed March 4, 2014).

"The West." http://www.pbs.org/weta/thewest/people/i_r/marshall.htm (accessed February 23, 2014).

Oral

Allen, Ed. James Marshall interpreter at Gold Discovery Days, Coloma, January 24, 2014.

Anderson, Lou. Interview with Linda J. Bottjer. Personal interview. Placerville, January 3, 2014.

Arcona, Melissa and Jill Barnes. Interview with Linda J. Bottjer. Personal interview. Placerville, December 26, 2013.

Berger, Marianne and Hans-Georg Dankers. Interview with Linda J. Bottjer. Personal interview. Georetown, February 12, 2014.

Burns, Gary. Interview with Linda J. Bottjer. Personal interview. Cameron Park, March 6, 2014.

Cameron, Dave. Interview with Linda J. Bottjer. Personal interview. Placerville, September 17, 2013.

Carroll, Tom, and Cindy Carroll. Interview with Linda J. Bottjer. Personal interview. Placerville, November 19, 2013.

Clark, Patty. Interview with Linda J. Bottjer. Personal interview. Placerville. January 13, 2014.

Cotenos, Bob. Interview with Linda J. Bottjer. Personal interview. Georgetown, November 1, 2013.

Crystal. Interview with Linda J. Bottjer. Personal interview. Placerville, December 5, 2013.

Darr, Hannah. Interview with Linda J. Bottjer. Personal interview. Placerville, January 8, 2014.

Davison, Larry. Interview with Linda J. Bottjer. Personal interview. Placerville. February 4, 2014.

Dougherty, J.T. Interview with Linda J. Bottjer. Personal interview. Placerville, November 27, 2013.

Fausel, Deanna, and Albert Fausel. Interview with Linda J. Bottjer. Personal interview. Placerville, December 21, 2013.

Foster, Mitch, Anne Roos and Kathy Benzon, Interviews with Linda J. Bottjer. Personal Interviews, Placerville, December 26, 2013.

Grace, Mara. Interview with Linda J. Bottjer. Personal interview. Placerville, February 12, 2014.

Guthrie, Kari. Interview with Linda J. Bottjer. Personal interview. Placerville, October 26, 2013.

Hardy, Lanny. Interview with Linda J. Bottjer. Personal interview. Placerville, October 12, 2013.

Harris, Amy. Interview with Linda J. Bottjer. Personal interview. Cameron Park, January 30, 2014.

Hill, Yolande. Interview with Linda J. Bottjer. Personal interview. Georgetown, November 1, 2013.

Hodges, Chris. Interview with Linda J. Bottjer. Personal interview. Placerville, December 19, 2013.

Hopkins, Linda. Interview with Linda J. Bottjer. Personal interview. Placerville, March 13, 2014.

Huff, Sonya. Interview with Linda J. Bottjer. Personal interview. Placerville, January 14, 2014.

Kessler, Gerald. Interview with Linda J. Bottjer. Personal interview. Placerville, November 20, 2013.

Meader, Mary and Jeff, Christine Webster and Cheryl Bence, Interview with Linda J. Bottjer. Personal interview. Placerville, February 4, 2014.

Micheals, Tom. Interview with Linda J. Bottjer. Personal interview. San Francisco. March 11, 2014.

Oliver, Robert and Millie. Interview with Linda J. Bottjer. Personal interview. Camino, January 10, 2014.

Peabody, George. Interview with Linda J. Bottjer. Personal interview. Placerville, March 5, 2014.

Schroth, Mary Ann. Interview with Linda J. Bottjer. Personal interview. Placerville, December 3, 2013.

Taylor, Tim, and Sue Taylor. Interview with Linda J. Bottjer. Personal interview. Placerville, January 30, 2014.

Teurman, Devyn. Interview with Linda J. Bottjer. Personal interview. Georgetown, November 1, 2013.

ABOUT THE AUTHOR

Linda J. Bottjer, a native New Yorker, has loved history since childhood. Her other passion of travel has allowed her to visit many historical places worldwide. Treasured souvenirs are collecting and sharing the stories of the famed, infamous and uncelebrated. As a freelance writer, her work has appeared with *CBS News, Travel & Leisure,* the *New York Times Regional Newspaper Group* and *Healing Quest,* a syndicated PBS series. Currently, she is the owner of Gold Rush Tales, a tour company based in Northern California. The Ghost Tours of Placerville, Grapes and Graves and Walking with the Dead tours regularly invite people to meet the spirited deceased residents of major Mother Lode towns.

Visit us at
www.historypress.net
...

This title is also available as an e-book